IMAGES
of America

WOODBROOK HUNT CLUB

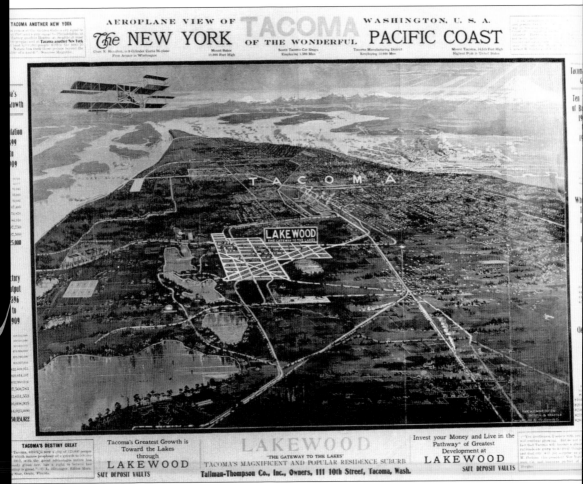

THE PRAIRIE SOUTH OF TACOMA. Many of the historical articles regarding horseback riding in the Tacoma area refer to the "prairie south of Tacoma." This c. 1910 bird's-eye view shows the prairie south of Tacoma and south of Lakewood, the setting for this book and the club's rich history. (Courtesy Tacoma Public Library.)

ON THE COVER: Riders return home around 1940 in the shadows of Mount Rainier after 20 miles of riding to the hounds across the Nisqually Prairie. This centuries-old tradition illustrates the timelessness and solitude of this unique ecosystem known as the Nisqually Prairie, located south of Tacoma and Lakewood on the Fort Lewis Military Reservation. (Courtesy Woodbrook Hunt Club.)

IMAGES
of America

WOODBROOK
HUNT CLUB

Joy Keniston-Longrie

ARCADIA
PUBLISHING

Published by Arcadia Publishing
Charleston SC, Chicago IL, Portsmouth NH, San Francisco CA

Printed in the United States of America

Library of Congress Catalog Card Number: 2008932144

For all general information contact Arcadia Publishing at:
Telephone 843-853-2070
Fax 843-853-0044
E-mail sales@arcadiapublishing.com
For customer service and orders:
Toll-Free 1-888-313-2665

Visit us on the Internet at www.arcadiapublishing.com

*This book is dedicated to my family, whose historical stories inspire me:
George and Violet Keniston, Dick and Lorraine Keniston,
Liz Sisul, and Albert James Kelly.*

CONTENTS

ACKNOWLEDGMENTS

This book would not be possible if not for the original photographers who documented our rich history so well and had the foresight to donate their collection to be properly preserved, archived, and accessible to the public: the Richards Studio, Asahel Curtis, Boland, Bowen, French, and Treat Collections. Special thanks to the people who cheerfully assisted me with access to historic material: the Tacoma Public Library, Northwest Room, with special thanks to Bob Schuler, Brian Kamens, Jeanie Fisher, and Jody Gripp; Elaine Miller, Washington State Historical Society (WSHS); Carolyn Marr, Seattle Museum of History and Industry (MOHAI); Janda Volkmer, Lakewood Historical Society; Bill Rhind, curator, Fort Nisqually Living History Museum; Dr. Bret Ruby, Fort Lewis Public Works; University of Washington Special Collections; Alan Archambault, Fort Lewis Military Museum; Aimee Summers, the Museum of Hounds and Hunting, Morven Park; Andrew Gough, British Library; Robin Stanton and Patrick Dunn, The Nature Conservancy; Benjamin Helle, Washington State Archives; and Scott Daniels, Oregon Historical Society.

Special thanks go to past and current Woodbrook Hunt Club members: Cyrus Happy III; Jean Brooks; Mike Wager; Allen Amoroso; Darlene Woods; Jennifer Hansen; Michaela Hansen; Carol Masters; Joanne Herrigstad; Linda Piper; Harriet Davis; Chester Thorne Corse; Fred Kingwell; Sue (Butts) Wohlford; Larry and Sharon Michelson and Kim Estrada (Brookwood Equestrian Center); Cecelia Svinth Carpenter (Nisqually Indian historian); Andy Towell (Troutstreaming Photography); Tim Poulsen (Poulsen Photography); Drew Crooks; Karen Haas; Felicidad Langston; Kathleen Smith; Anne Harris; Laurie Selden Lennox; Col. Barbara Guller; and Arnold and Patty Authement. I would like to extend special acknowledgment to Ron Karabaich at Old Town Photo for his technical assistance with the images, and to Bill Evans, Tacoma city councilman and owner of the Pacific Northwest Store, who encouraged me to pursue this project.

Last, but certainly not least, a special thank-you goes to my family—Mark, Kelsey, and Amberose Longrie; Lorraine Keniston; Joan and Bob Weaver; Rick, Andrea, Karen, Kelly, and Brian Keniston; Joan and John Sisul; and Mary Longrie—for their interest and support throughout this whole process.

The following organizations have been abbreviated within this book:

HBC	Hudson Bay Company
MOHAI	Museum of History and Industry
WHC	Woodbrook Hunt Club
WSHS	Washington State Historical Society

INTRODUCTION

People driving between Tacoma and Olympia on Interstate 5 often do not realize they are passing through one of the most historic areas in the region. Drivers are focused on getting to their destination in either of two conditions: a stop-and-go traffic jam on I-5 or, if traffic is good, ensuring safe speeds to avoid radar traps on the I-5 corridor near Lakewood. Many people avoid I-5 altogether and never venture to the "other side" of I-5. The construction of I-5 in the 1960s, combined with Fort Lewis Military Base, created a physical and psychological barrier that has kept most people and growth away. Due to urbanization, many people do not realize Lakewood is located on prairie land or that the vast prairie south of Tacoma once extended all the way to Chehalis. Many people do not realize that some of the best equestrian facilities and cross-country terrain in the Pacific Northwest are located just off I-5 at the exits of Gravelly Lake, Thorne Lane, and Bridgeport Way.

The prairie south of Tacoma, Nisqually Plain, has played a significant role in the history of this area for centuries. Horses have also had an important role on these grassy plains in terms of social, economic, land use, transportation, political, and recreational activities. This book shares a pictorial story of how a strange turn of events brought three different nations, the Nisqually Nation, Great Britain, and the United States, together in time and place to create and continue traditions of horse and people in Pierce County, Washington state.

The historic link of early Tacoma leaders and the Lakewood area is particularly strong, as the Lakewood area was the summer and leisurely playground for many people from near and far, both the rich and the poor. The Woodbrook Hunt Club (WHC) and Woodbrook Riding Academy have played a central part in the recreational pursuits of many in this area for nearly a century.

The history of the prairie and the horse are intertwined with adventure, politics, economics, and social and environmental threads. This is a story of timelessness and tremendous change. If the prairie grass waving in the winds could speak, it would tell a tale of cultures coming together on the prairie, much change, and sameness. The tale is of trade, life, death, sorrow, love, war, joy, and of horses, people, and machines. The bonding element is the place, the prairies south of Tacoma. This is a story of that place, "the prairie south of Tacoma," and the history of events and tradition that shaped this prairie to be what it is today. The legacy inherited from our forefathers and mothers is one to be cherished and protected for future generations. It is indeed a strange set of circumstances that has led to an outcome, somewhat intentional but mostly by chance, which has had a profound impact and regional significance on the quality of life, habitat, and ecosystems of the prairie.

The story of the prairie begins with the geologic history of Nisqually Prairie and the Native American people who lived there for centuries. The introduction of the horse to the Nisqually Prairie created significant cultural, social, and economic changes for the Nisqually people. The Nisqually was the only tribe in the Puget Sound area who had tremendous natural prairie grasslands to support horses. Horses were highly esteemed in the culture, and members with horses were considered wealthy and highly regarded. Horses also brought much recreational enjoyment and

7

entertainment. Not only did the Nisqually people race each other, but inter-tribal horse race events were also popular.

The prairie landscape, combined with location, attracted the British, who chose to establish Fort Nisqually on these same prairies. The British brought their own customs and enthusiasm for the horse in terms of commerce and transportation as well as recreational pursuit, along with a penchant for scarlet coats and top hats that has endured for centuries.

This same attraction to the prairie in the shadows of Mount Rainier once again lured settlers and the U.S. military here. The military used horses extensively in the area until it was fully mechanized in World War II. It is because of the military presence that the last three percent of what were vast areas of prairie lands still exists south of Tacoma today and that the oldest hunt club west of the Mississippi maintains its presence.

One

THE PRAIRIE
HISTORICAL CONTEXT

The prairies south of Tacoma have played a significant role in the history of this area for centuries. Horses on the Nisqually Prairie have created cultural change, participated in significant events, and helped shape the history of this region between three nations: Nisqually, Great Britain, and the United States.

The Nisqually Prairie was first inhabited by the *Squally-absch*, or Nisqually people, meaning "people of the grass country." They occupied the Nisqually Watershed between Mount Rainier (*Tacobud* or Tahoma) and Puget Sound (the *Whulge*), and they were the only Native American tribe in the Puget Sound basin with significant prairie land. The horse—called *sti-a-ke-ya* in Nisqually and *kiceatan* in Chihook jargon—was first introduced to the area in the early 1800s when Nisqually chief Leschi's father, Yanatco, married a Yakama Indian maiden, Cornucita, and received several horses as a gift. The Nisqually people frequently held horse races with the Yakama tribe on the Nisqually Prairie.

The British Hudson's Bay Company (HBC) established Fort Nisqually in 1833 on the Nisqually Prairie. By the 1840s, Fort Nisqually employees and British sailors established a race course called "Race Course Plain" and enjoyed racing against the Nisqually and Yakama people. The HBC journals record five large herds of wild horses running upon the Nisqually plains, each led by a stallion of fine appearance.

The Nisqually Prairie officially became a part of the United States in 1846. The 1850 Donation Land Act promoted homestead settlement in the Pacific Northwest. One of the early homesteaders, Thomas Dean, an HBC employee, claimed 320 acres in Pierce County at the location of the HBC Tlithlow Outstation. Thomas Dean's claim became a popular place to gather for horse racing on Sundays.

When Washington became a state in 1889, one of the first acts of the Washington State Legislature was to establish a military department of Washington. Beginning in 1890, encampments and maneuvers involving large numbers of men and horses were held near American Lake, resulting in the establishment of Camp Murray in 1904 and a local vote in 1917 to establish Fort Lewis. Fort Lewis's land management has helped ensure that the native habitat did not succumb to the rapid development that was to occur in the rest of the Puget Sound corridor during the ensuing century.

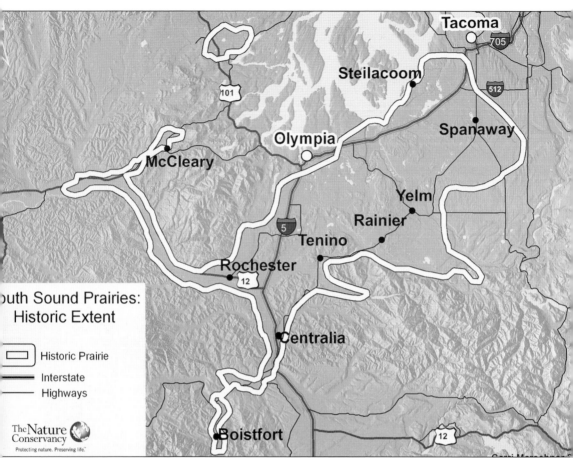

GLACIERS CREATED PRAIRIE. Ice one mile thick covered the areas currently known as Tacoma, Lakewood, and the Puget Sound nearly 16,000 years ago. The melting of the glaciers combined with weather patterns created geology that resulted in a unique prairie landscape and ecosystem. Glacial deposits left gravelly soils, poor top soils, and unprotected aquifers. This area supports an extensive series of creeks, streams, rivers, wetlands, and lakes. The original South Puget Sound Prairie region extended from south of Tacoma to north Lewis County, encompassing over 150,000 acres in prairie habitat. This landscape is in sharp contrast to the heavily forested area dominating the Puget Sound landscape. Grass, wildflowers, camas root, oak trees, and acorns were essential, basic resources in the Nisqually Indians' diet, supplementing fish and wildlife abundantly found on the Nisqually Plain and waters. (Courtesy of The Nature Conservancy.)

SQUALLY-ABSCH PEOPLE. The Nisqually people called themselves Squally-absch, meaning "people of the grass country, people of the river." This map illustrates the Squally-absch territory and the Whulge, the Nisqually word for what is now known as Puget Sound. The Nisqually territory extended from what today is known as Parkland-Spanaway to Tenino, Mount Rainier, and the marine waters of Puget Sound. (Courtesy Cecelia Svinth Carpenter.)

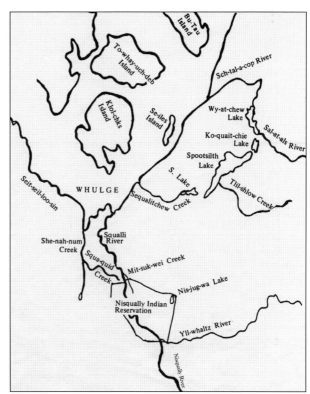

INTRODUCTION OF THE HORSE TO NISQUALLY PRAIRIE. The horse was first introduced into the Nisqually tribe as a wedding gift from the Yakama tribe when Chief Leschi's father married a Yakama Indian maiden in early 1800. The horse significantly impacted Nisqually life. Horses helped speed transportation and communication, and created tribal unity. Villages would come together to practice their skills, and horse racing became a favorite sport. (Courtesy WSHS.)

CHIEF LESCHI. Chief Leschi's father owned many horses, and the family was held in high esteem. Chief Leschi and his brother, Quiemuth, would later work for HBC taking care of their horses on the Nisqually Prairie. Leschi would become the most important figure in Nisqually political history when he went to war with the United States to secure prairie land for his people. (Courtesy Cecelia Svinth Carpenter.)

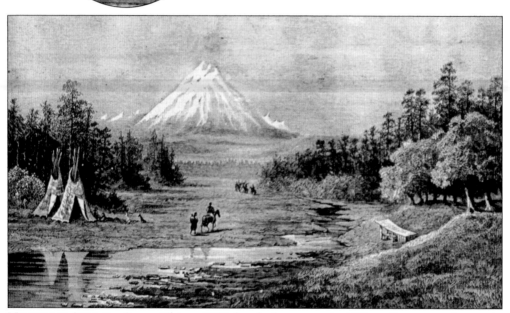

NISQUALLY SUMMER CAMP. This *c.* 1850 sketch shows a typical Nisqually summer home, in tipi shape with slender poles covered with strips of cattail matting, which was used for trips to summer berry fields. This summer camp, located on Clover Creek near Gravelly Lake, illustrates the important role the horse played in daily life. The Nisqually seasonally burned the prairie to sustain prairie grass, roots, bulbs, nuts, oak, and other vegetation to supplement their diet. (Courtesy Lakewood Historical Society.)

FORT NISQUALLY. The HBC established Fort Nisqually in 1833 for fur trading. The top hat was quite a popular fashion in Britain during this era, and the need to find beaver pelts to make top hats was a driving factor in the fur trade. They expanded their role to agricultural activities in 1839, and this image, *Nisqually, a Village on Puget Sound* by Paul Kane (1810–1871) dates to around 1847. (Courtesy Stark Museum of Art, Orange, Texas. 31.78/47.)

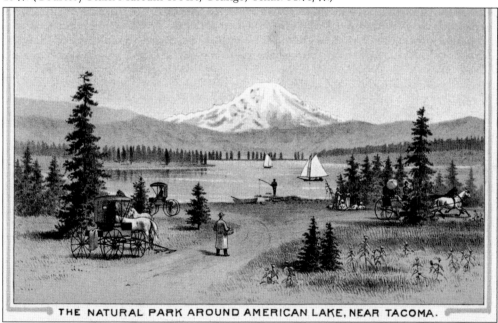

THE NATURAL PARK AROUND AMERICAN LAKE, NEAR TACOMA.

AMERICAN LAKE. The July 4, 1841, HBC entry in the *Journal of Occurrences* notes, "Lt. Commander Wilkes, . . . wishing to give his crew a holiday . . . marched off with flags flying and music playing. . . . The amusements of . . . horse racing, a sports always in favor with Jack ashore. Of course they had tumbles off the wild horses provided by the Indians . . . but no one was injured. . . . from that time it has been known as American Lake." (Courtesy WSHS.)

Social and Economic Impact. The establishment of Fort Nisqually in 1833 rapidly became an important catalyst for a variety of new regional economic relationships once trading operations began. Chief Trader Archibald McDonald wrote on June 14, 1833, "A good deal of stir about. . . . canoes arriving by sea—dozens of horses and riders by land." Eventually, many Nisqually tribal members worked for the HBC. (Courtesy WSHS.)

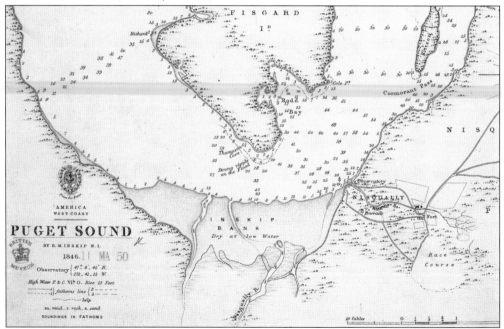

Horse Race Course. This 1846 British map of Fort Nisqually illustrates the important role the horse held for the British and local tribes. Horse racing was a favorite recreational pastime of the ship's crew, who would hire horses and race the Nisqually and Yakima. Names are different from the Squally-absch (Nisqually) map and are distinct still from the names today. (Courtesy British Library.)

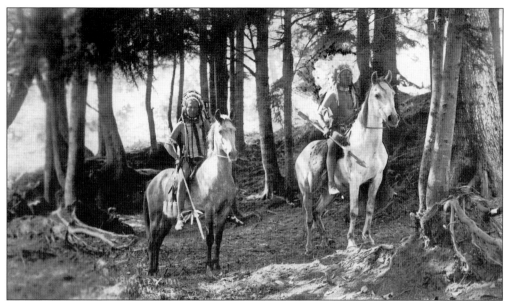

INDIAN GUIDES. Theodore Winthrop, visiting Fort Nisqually in 1853, wrote in *The Canoe and the Saddle*, "We heard a resonance of hoofs . . . a noise of galloping sounded among the oaks. Presently a wild dash of Indian cavaliers burst into sight . . . a-flutter with ribbons, fur-tails, deerskin fringes, trailing lariats, and whirling whip-thongs . . . stampeding toward us from under the mossy oaks. They came, deployed in the open woods, now hidden in a hollow, now rising a crest, all at full gallop, loud over the baked soil—a fantastic cavalcade." (Courtesy WSHS.)

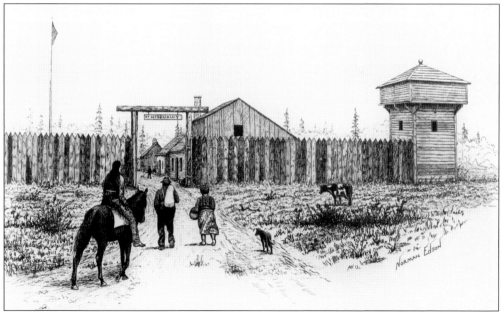

FURS TO FARMING. In 1839, the HBC established the Puget Sound Agriculture Company to offset the expensive cost of importing food and to grow foods locally. In 1841, a British military officer traveling between Cowlitz Farm and Fort Nisqually noted, "The large level plain was alive with cattle and with Indians galloping about in every direction." (Courtesy University of Washington Special Collections.)

The plain upon which the races took place was always — in the Company's time — called the "Race Course plain." Of course I was not here at the time of these races, but Dr. Tolmie told me all about the sports. The Officers — or some of them — would attend the races, dressed in the usual English riding (gentlemanly) Costume, very much to the delight of the indians, who flocked to these races in large numbers. They came from away back on the other side, bringing fast horses to run against the "Shipmen" and the "Horse indians" of Puget Sound.

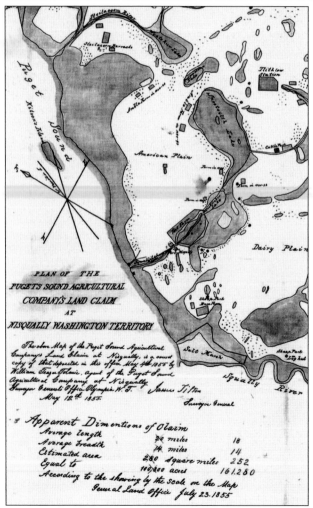

EDWARD HUGGINS LETTERS. A portion of the letter above reads, "The plain upon which the races took place was always—in the company's time—called the 'Race Course Plain'. . . . The officers—or some of them—would attend the races, dressed in the usual English riding (gentlemanly) costume, very much to the delight of the indians, who flocked to these races in large numbers. They came from away back on the other side, bringing fast horses to run against the 'Shipmen' and the Horse indians of Puget Sound." (Courtesy Oregon Historical Society.)

TLITHLOW. The HBC's Tlithlow Outstation is identified on this 1855 Puget Sound Agricultural Company Map of Land Claims. Walter Ross, Tlithlow's manager in 1851, was succeeded by Thomas Dean. Dean made a donation land claim on the Tlithlow property, which became a venue for regular Sunday horse race events. (Courtesy Washington State Archives, Olympia Regional Branch.)

ROSS FAMILY PHOTOGRAPH.
This *c.* 1870 picture is of
Charley Ross, brother to
Walter Ross, a manager of
Tlithlow. Charley married a
Nisqually maiden, Catherine
Tumalt Ross. Charley Ross and
Catherine Tumalt Ross are the
great-grandparents of Cecelia
Svinth Carpenter, a Nisqually
tribal elder and historian.
Carpenter rode horses on the
prairie as a girl. (Courtesy
Cecelia Svinth Carpenter.)

**NISQUALLY LEDGER OF
HORSES.** Bill's Blonde—also
known as Le Blonde—in
the top entry at left, owned
by Dan Mounts, manager of
the Nisqually Reservation
from 1857 to 1860, raced
against Native American
horses and generally beat
them. Edward Huggins, an
HBC employee in charge of
maintaining the *Journal of
Occurrences*, wrote in 1865,
"Settlers often attended
horse races and Indian
horses often, in fact nearly
always, beat the white man's
horses." In 1863, Race Horse
Plain hosted a race between
Le Blonde and Native
American horses. (Courtesy
Fort Nisqually Foundation.)

17

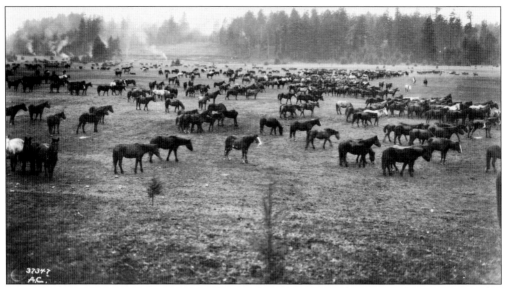

ANNUAL WILD HORSES ROUNDUPS. The rich bunch grass of the Nisqually Prairie provided excellent pasture for the horses, and many wild herds roamed the prairies. Annually the Nisqually tribe, and later the military, would round up the wild horses to select the best for their daily and recreational uses. These wild horses were rounded up on the prairie near Woodbrook around 1916. (Courtesy WSHS, 37347AC.)

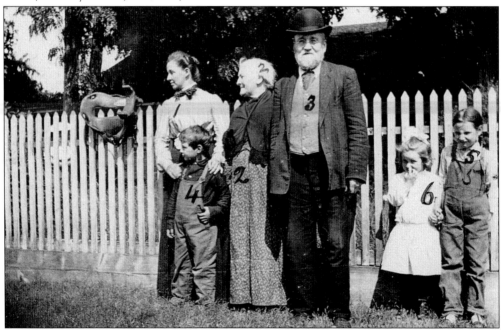

SIDESADDLE. Pictured around 1905 are Edward Huggins, his wife, Letitia Work Huggins (third from left), and family in front of their home on the Nisqually Prairie. Huggins made several entries in the *Journal of Occurrences* regarding a sidesaddle—perhaps the one on the fence—which was made for and used by Mrs. Tolmie and later by Letitia Work Huggins. Mrs. Tolmie was the wife of Dr. William Tolmie who was in charge of HBC's Fort Nisqually post. The journal indicates that she used the sidesaddle to ride across the prairies south of Tacoma. (Courtesy Dr. Johnstone family collection.)

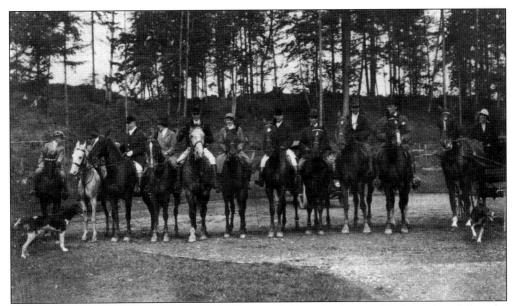

SEATTLE-TACOMA JOINT HUNT. By 1910, Thomas H. Bryan had trained foxhounds to follow the scented bag across the prairie. Prominent leaders Chester Thorne, Everett Griggs, Henry Hewitt, and Dr. Yocum hosted the Seattle Hunt Club members for a drag hunt on the prairies. It was so successful that millionaire Harry Treat, Master of Fox Hounds, Seattle Hunt Club, threatened to take the Tacoma hounds north to Seattle. (Courtesy MOHAI.)

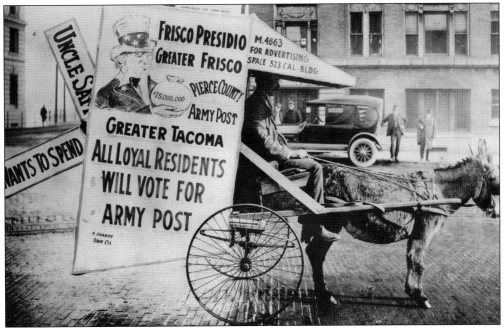

CAMP LEWIS. This campaign sign urges people to vote in the 1917 election to establish a U.S. Army post on the lands south of Tacoma. The vote passed, forcing many early settlers and Nisqually Indians to move with short notice. Many Nisqually Indians were forced to move again. Their chief, Leschi, lost his life trying to help his people retain their lands. (Courtesy Tacoma Public Library.)

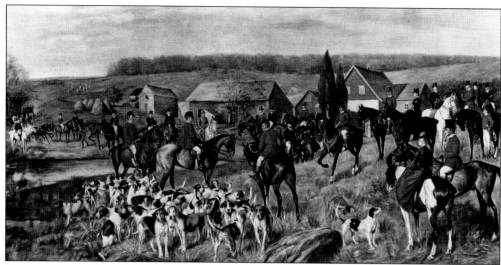

RIDING TO THE HOUNDS, FOX HUNTING. The British tradition of riding to the hounds has been documented to date before the 1400s in England, Scotland, and Ireland. The traditional red coats reflect the color of royalty, and top hats were the fashionable statement of noble gentlemen. England's sport of foxhunting spread to the colonies and was popular there long before the Revolutionary War. (Courtesy Morven Park, Museum of Hounds and Hunting.)

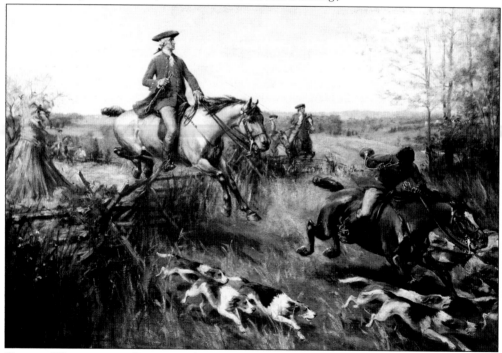

GEORGE WASHINGTON. George Washington was an ardent foxhunter who owned his own pack of hounds; his diaries are laced with references to foxhunts near the nation's capital. This c. 1770s image, *First Gentleman of Virginia: George Washington at the Hunt* by John Ward Dunsmore, was a gift from George A. Zabriskie Memorial in 1936 to the Fraunces Tavern Museum. (Courtesy of Fraunces Tavern Museum, New York City, 1909; 2006 conservation treatment sponsored by the Masters of Foxhounds Association of North America, New York City.)

Two

THE FOUNDERS

In the spring of 1926, Maj. J. E. Mathews and Thomas Bryan formed the Woodbrook Hunt Club (WHC). After the first year of inception, the WHC had 75 members representing horse enthusiasts from the local area as well as Seattle, Everett, Aberdeen, Portland, and Canada. It became an immediate hit on the social scene and was frequently featured in the society pages of the Tacoma and Seattle newspapers.

Although formally established in 1926, its roots go back to 1892 when the Tacoma Riding Club hosted its first paper chase. However, the idea of drag hunting took hold in 1910 when Bryan hosted the Seattle Hunt Club at a drag hunt on the prairies south of Tacoma. A drag hunt consists of a burlap bag impregnated with animal scent and dragged over the ground. The enthusiasm was so great that the Seattle group jokingly threatened to take the Tacoma hounds north to Seattle. Based on this success, drag hunts were held frequently from that point on.

While there was enthusiasm for the drag hunts, there was a lack of a millionaire in sight, resulting in the formation of the WHC as a means to provide structure and financial support to offset the costs of caring for the hounds and numerous social activities popular with the hunt tradition. The first WHC Board of Directors included Hill Hudson, president; Iris Bryan, huntsman; Katherine Rice, vice president; T. H. Bryan, Master of Fox Hounds (MFH); Maj. J. E. Mathews, secretary treasurer; and Capt. W. C. Proby and Bunney Mathews, whippers-in. The Committee of Hunts members were E. M. Nyman and W. A. Miller. These local leaders and skilled horsemen/women were the nucleus of what would become the oldest hunt club west of the Mississippi, strategically located near Fort Lewis and thousands of acres of prairie lands. The WHC is registered with the Master of Fox Hounds Association of America and has permission from the commanding general to access Fort Lewis.

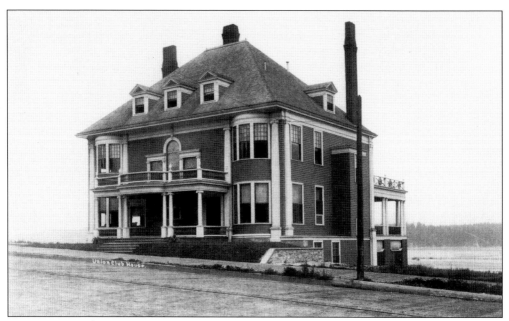

UNION CLUB. Thomas H. Bryan, a skilled horseman, left County Cork, Ireland, to seek his fortune in the 1897 Alaskan gold rush. Bryan arrived in Tacoma in 1900 with $60 and promptly spent $55 on a horse. Some say it is a wonder he did not spend the other $5 for a hound. He got a job managing the prestigious Union Club, established to further business connections in Tacoma. (Courtesy Tacoma Public Library.)

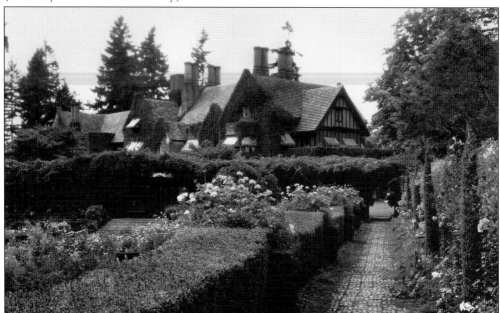

THORNEWOOD ESTATE AND GARDENS, C. 1925. Millionaire Chester Thorne became acquainted with Thomas Bryan at the Union Club. They soon discovered a shared interest in horses and hounds. Thorne hired Bryan as the superintendent of Thornewood Estates, located on American Lake, to maintain the beautiful Olmstead brothers–designed grounds, including the private stables. Chester Thorne was a founding member of the WHC. (Courtesy Tacoma Public Library.)

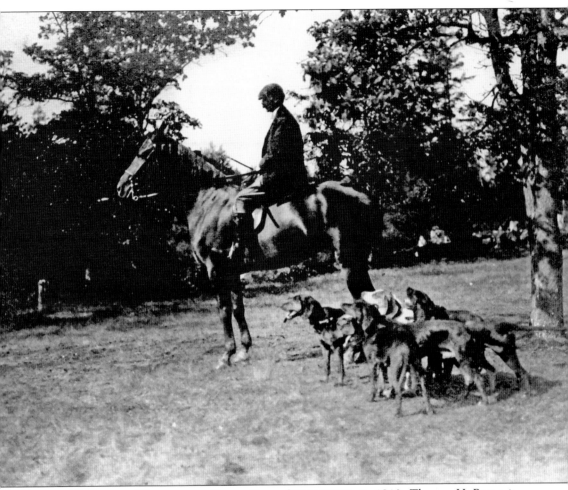

THOMAS H. BRYAN, WOODBROOK HUNT CLUB COFOUNDER, C. 1910. Thomas H. Bryan is pictured here on his horse, surrounded by his cherished hounds on the prairie with oak trees in the background. Bryan, from County Cork, Ireland, was an accomplished horseman and foxhunter in the old country, where he worked on large estates managing horses, hounds, and hunts. Bryan trained and donated the pack of hounds to the WHC. The club drew its membership from Captain Proby's Riding Academy, the cavalry unit at Fort Lewis, and the Washington National Guard, Troop B. People who remember Bryan say he was a typical Irishman. He was kind, had a good sense of humor and a great love of horses and hounds, and always wore a white starched shirt. He dedicated his life to teaching his daughter, Iris, all he knew of horses and hounds, as well as to the nurturing of the hounds, the drag hunt, and the WHC. Bryan coined the name Woodbrook Hunt Club. (Courtesy WHC.)

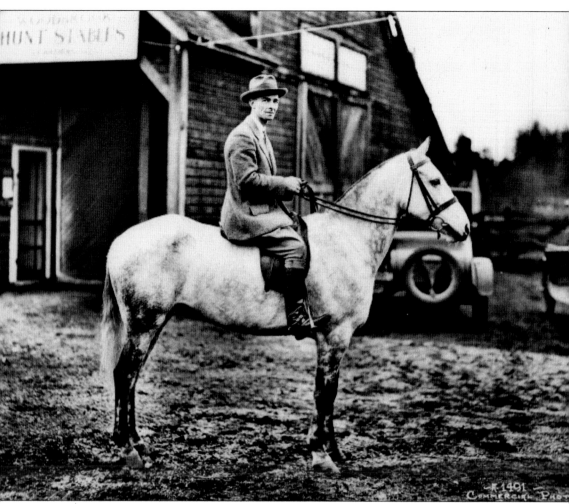

MAJ. J. E. MATHEWS, WOODBROOK HUNT CLUB COFOUNDER, C. 1926. Maj. J. E. Mathews was a native of Victoria, British Columbia, Canada. He attended the Royal Military Academy and served overseas in World War I. He came to Tacoma in 1924 and opened his first riding academy at the Tacoma Country Club's old barn in conjunction with Capt. William Carysfoot Proby, also from Victoria. The business grew, and they moved it to Eighty-seventh Street and Union Avenue (South Tacoma Way). Mathews is on his horse by Woodbrook Hunt Stables at the Eighty-seventh Street and Union Avenue location. Notice the "Hunt" sign in the left-hand corner. Mathews, owner of the future Woodbrook Riding Academy, donated property for the WHC Clubhouse. Mathews owned and operated the Woodbrook Riding Academy and was an active member, officer, and rider in the WHC from the time of its inception in 1926 until Major Mathews had to return to Canada in 1940 to assist with World War II efforts. (Courtesy Tacoma Public Library.)

Captain
W. C. PROBY
Riding Master

J. J. PROBY

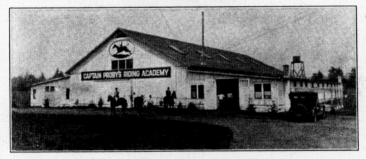

On Main Highway, 87th St. & S. Union Av.
TACOMA, WASHINGTON

RENTING – TEACHING – BOARDING

Large indoor riding ring
Well trained saddle horses
The highest grade of service
at moderate rates

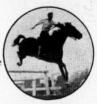

WOODBROOK HUNT & POLO CLUB RUN IN CONNECTION

Postal Address
P. O. Box 772
Tacoma

Phone
Madison
195-J4

POLK DIRECTORY ADVERTISEMENT. This 1926 advertisement illustrates the connection between Captain Proby's Riding Academy and the Woodbrook Hunt and Polo Club. All four activities (riding lessons, boarding, hunting, and polo) are dependent upon each other for facilities, trained horses, and skilled riders. In 1926, the Eighty-seventh Street and Union Avenue location was still considered prairie, yet had close proximity to the rapidly growing city of Tacoma to draw business. (Courtesy Tacoma Public Library.)

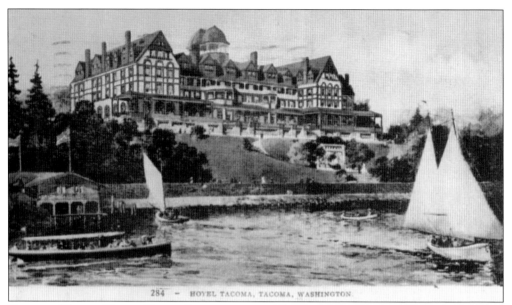

TACOMA HOTEL HOSTS HUNT CLUB, C. 1909. The founding members of the WHC were from the social elite. The setting of their first annual meeting reflects the social status, as well as the social prestige, the Tacoma Hotel had in the region. The Tacoma Hotel, set on the bluff overlooking Commencement Bay and Mount Rainier, was built in 1884 and was considered the finest hotel north of San Francisco. It was destroyed by fire in 1935 and was never rebuilt. (Courtesy Tacoma Public Library.)

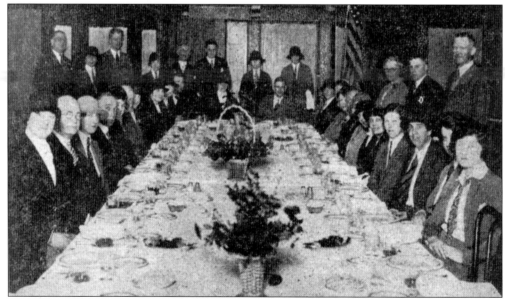

FIRST ANNUAL DINNER AT TACOMA. The elegant Tacoma Hotel was the location chosen by the WHC founders to hold their first annual meeting in 1926. Many prominent community members formed the initial WHC, including Chester Thorne, National Bank of Tacoma; Chauncey Griggs, St. Paul and Tacoma Lumber Company; General Alexander, commanding general at Fort Lewis; Dr. and Mrs. Yocum; Mrs. L. E. Titus, Titus-Will Automobiles; Mrs. F. R. Titcum, Weyerhaeuser; and Charles Hyde, West Coast Grocery. (Courtesy WHC.)

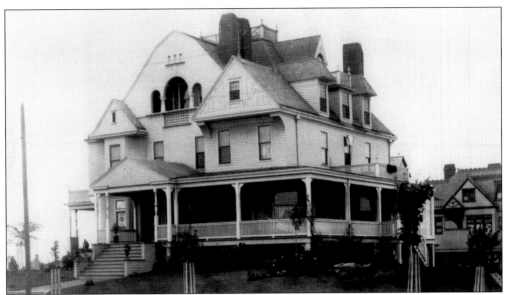

GRIGGS FAMILY TIMBER BARONS. Several descendants of Civil War veteran Col. Chauncey Griggs were founding members of the WHC. The Griggs family was noted for its role in the formation of Tacoma and in the establishment of the WHC's predecessor, the Tacoma Riding Club. Griggses were active in recreational riding dating back to 1892 "paper chases" and early drag hunts on the prairie in 1910 with the Seattle Hunt Club. Col. Chauncey Griggs was cofounder/president of the St. Paul and Tacoma Lumber Mill. Colonel Griggs's home (above), located on the corner of North Fourth Street and Tacoma Avenue near Stadium High School, was torn down in the 1950s for a new church. Below, Colonel Griggs stands on the left of an old-growth log around 1900 at a time when the supply of old-growth timber was believed to be endless. (Both images courtesy Tacoma Public Library.)

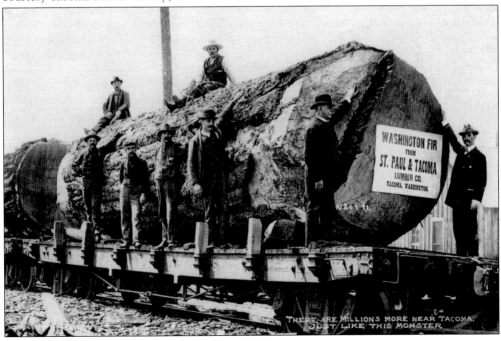

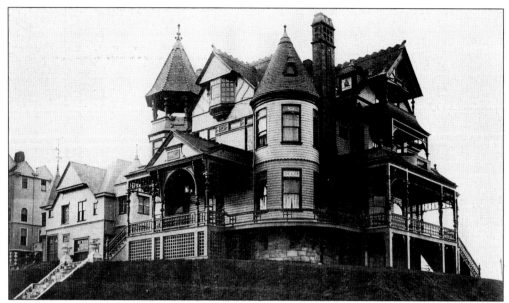

HEWITT FAMILY TIMBER BARONS, C. 1890. The Hewitt family was instrumental in the formation of the Tacoma Riding Club and early drag hunts. Future Hewitt generations who moved from the north end of Tacoma to the Lakewood area would be key leaders in the WHC. The Hewitt family's home, located on North Fourth and E Street near Stadium High School overlooking the bay, was considered to be the most exquisite home in Tacoma in the 1890s. Henry Hewitt was the cofounder of the St. Paul and Tacoma Lumber Mill along with Colonel Griggs, whose home can be partially seen to the far left. Below is a view of the mill located on Commencement Bay, also known as the "Mill on the Boot." This mill and family have played an important role in Tacoma since 1888. (Both images courtesy Tacoma Public Library.)

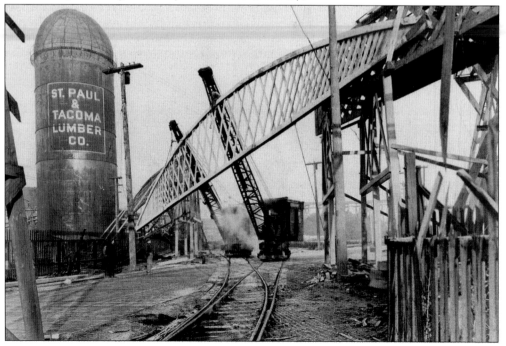

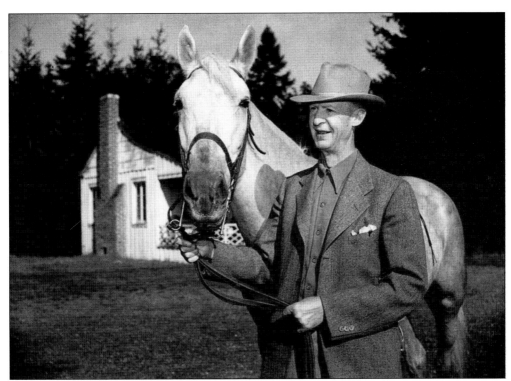

LEE L. DOUD, DEFIANCE LUMBER. Lee L. Doud was a founding member of the WHC and the first president of the club. He was an excellent horseman and rode his entire life. Doud was the secretary-treasurer and manager of the Defiance Lumber Company, located on Ruston Way in Commencement Bay. The Defiance Lumber Company, founded in 1905, was an export mill, which cut 80 million feet of lumber in 1926, the year the WHC was founded. It exported lumber to Europe, Australia, and South America, as well as serving the domestic market in the United States. Doud and his family initially resided in Tacoma's north end in the Proctor District at 2911 North Twenty-fifth Street and later moved to Gravelly Lake. (Courtesy Tacoma Public Library.)

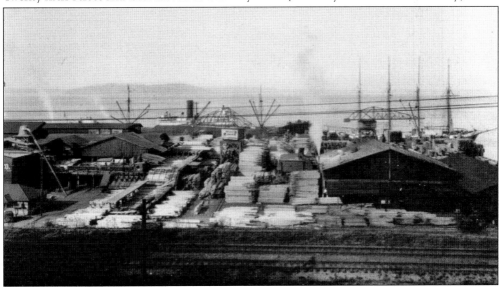

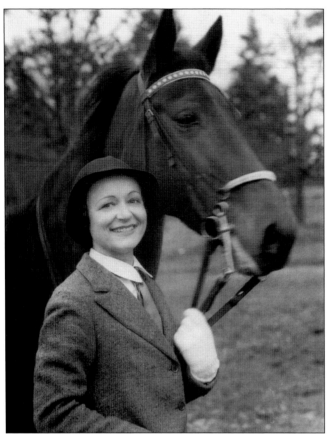

KENWORTHY GRAIN MILLING COMPANY, C. 1930. Fred J. and Hazel Kenworthy (at left) were both founding members of the WHC. Fred was president and Hazel was vice president of the Kenworthy Grain and Milling Company, located on South Fifty-sixth Street and Washington Street, one block west of South Tacoma Way. The Kenworthys resided at 604 North Eighth Street, an elegant Italian Renaissance home, blocks from the Griggs and Hewitt homes and across the street from Annie Wright Seminary. The Kenworthy Grain and Milling Company was built in 1905 as a wholesale and retail granary and feed mill. The company was bought out by General Mills in the 1940s. A portion of the building was reopened as the Brickyard Bar and Grill in the early 2000s. (Both images courtesy Tacoma Public Library.)

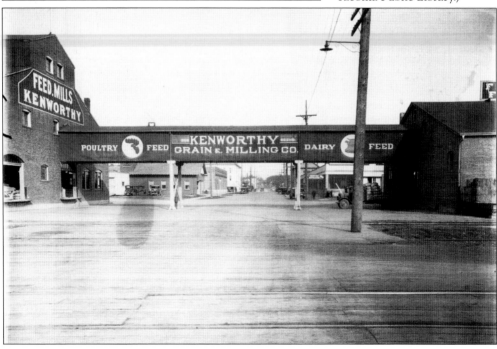

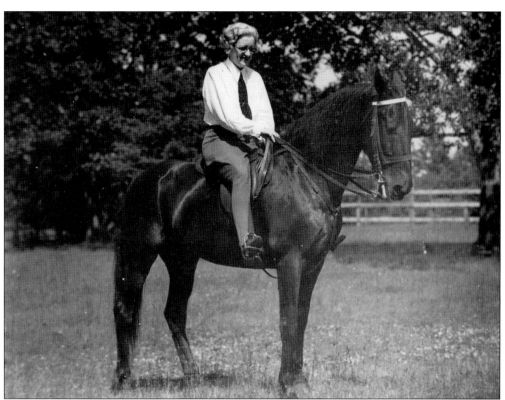

BONNELL CONSTRUCTION, C. 1935. Marguerite Bonnell was an avid horsewoman and member of the WHC her entire life. Her family's business was J. E. Bonnell and Sons, Inc., contractors who built many major construction projects in the Tacoma area, including Annie Wright Seminary, Tacoma General Hospital, University of Puget Sound, Bank of California, Tobey Jones, Lowell Elementary School, and St. Mark's Episcopal Church on North Gove Street, among other well-known landmarks. The Bonnells were listed as residing at 603 North Ainsworth Street in 1935. The 1924 Annie Wright Seminary, a girls' school, is featured at right as an example of a major icon the Bonnell and Sons construction company built. The Woodbrook station wagon picked up Annie Wright students here for weekly lessons. (Both images courtesy Tacoma Public Library.)

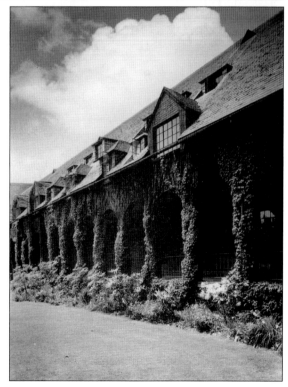

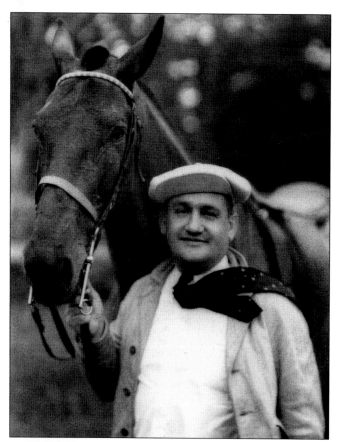

WALKER ELEPHANT HOUSE.
William Walker and his
daughter Roberta Walker were
early members of the WHC.
William served as president
in the early years. He was
the son of Robert and Emily
Stock Walker, cofounder of
Walker Cut Stone, Inc. The
Walker residence, below, at
3411 North Thirtieth Street,
is also known as the Elephant
House. Father and daughter
were avid riders and horse
enthusiasts. William is dressed
here in sporty equestrian
attire, reflective of his riding
skills and personality, around
1935. (Both images courtesy
Tacoma Public Library.)

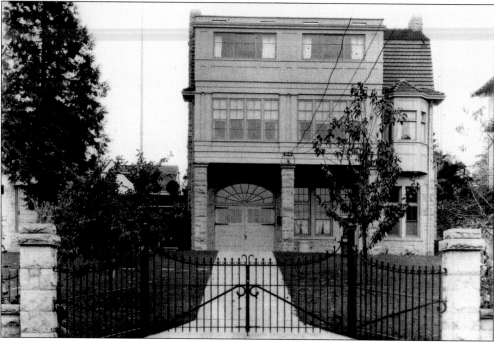

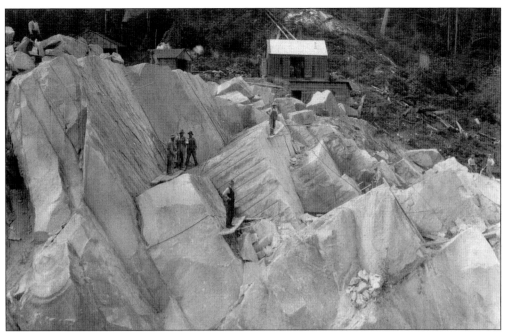

WALKER CUT STONE, INC. The growing region needed construction materials, and the Walker Cut Stone, Inc., operated a quarry in Wilkeson from 1914 to 1959, providing sandstone, building stone, and paving blocks. The company offices were located at 2403 Center Street, in Tacoma. Wilkeson sandstone was used as foundational stone and for other uses in residential and commercial buildings throughout the Puget Sound region. The picture above shows how the stone was extracted from the Wilkeson Quarry. The 1928 image below shows Walker cut stone on its way to Olympia for the construction of the Capitol building, which at the time was the largest exclusively stone building in America. (Both images courtesy Tacoma Public Library.)

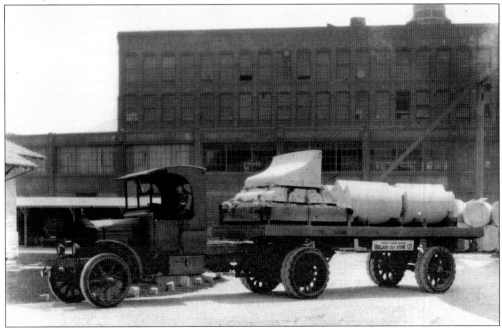

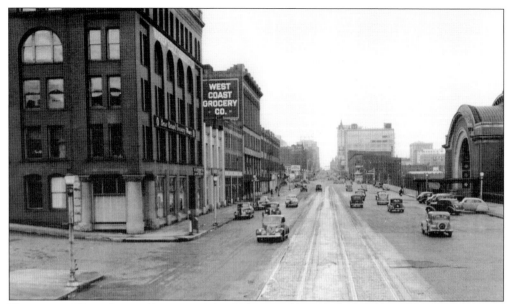

HYDE AND WEST COAST GROCERY. Mrs. Robert Hyde was a founding member of the WHC. Her husband, Robert Hyde, was president of West Coast Grocery, shown above. West Coast Grocery was located across from the Union Station on Pacific Avenue. Today the building houses a Starbucks. Mrs. Hyde was active in many social activities sponsored by WHC. The Hydes were neighbors of the Griggs and Hewitt's on Tacoma Avenue, shown below at 425 Tacoma Avenue North, near Stadium High School before moving to Scarlet Oakes, at 12753 Gravelly Lake Drive. The Hyde's son Charles was also a WHC member and played nolo/polo. (Both images courtesy of Tacoma Public Library)

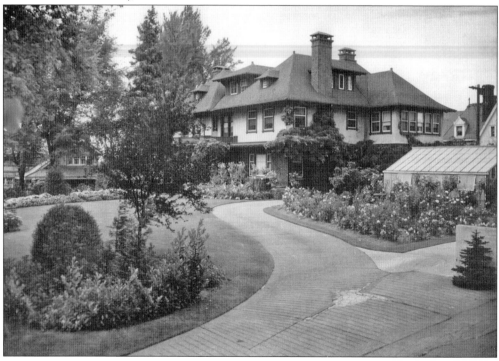

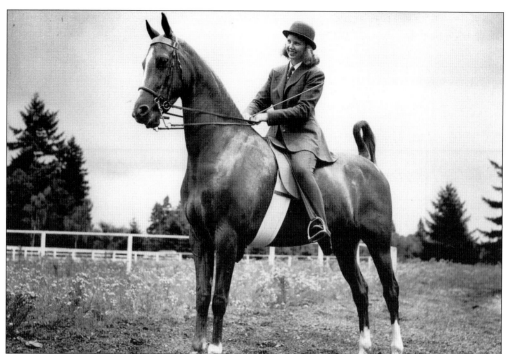

RUST FAMILY, C. 1907. Named after her grandfather William R. Rust, Tacoma Smelter magnate Billie Jean Rust was a lifelong horse enthusiast. She was the daughter of Margaret Smith and resided in the Lakewood district. In this picture, Billie Jean is home for summer break from college and is riding Guiding Moon, a Kentucky-bred horse. She was a WHC member for many years. The Rust Mansion, pictured below, was built in 1907 for William Rust. The home is an icon in Tacoma, along with the Ruston Asarco Smelter. The family only lived here for a few years. It was infamous during the Prohibition era for sponsoring speakeasies. It boasts a beautiful ballroom and large billiards room. It has been converted to condos and apartments over the years. (Both images courtesy Tacoma Public Library.)

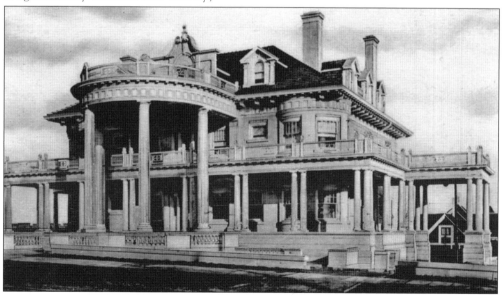

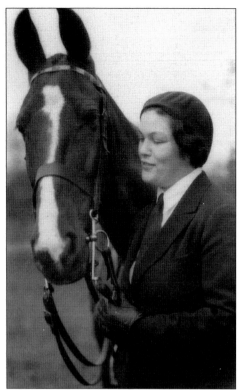

SCOFIELD SAND AND GRAVEL. Celia Grace Scofield, with her horse Gilt, was born in Tacoma to Celia and Harvey Scofield of Scofield Sand and Gravel. The family lived at 608 North Ainsworth Avenue in the 1920s. Celia often rode horses on the prairie south of Tacoma with her cousin Kathleen Barr Smith. While attending the University of Washington, Seattle, she rode at the Olympic Riding and Driving Academy. After college, she rode at the WHC and remained active in the equestrian scene her entire life. At 85, she began showing miniature horses; her last show was at the age of 89. Scofield Sand and Gravel, established by her great-grandfather George Scofield, distributed sand, gravel, cement, "Tru-Mix Concrete," reinforcing steel, and other building materials. The Ford truck featured in the image below was purchased from Titus Motor Company. (Both images courtesy Tacoma Public Library.)

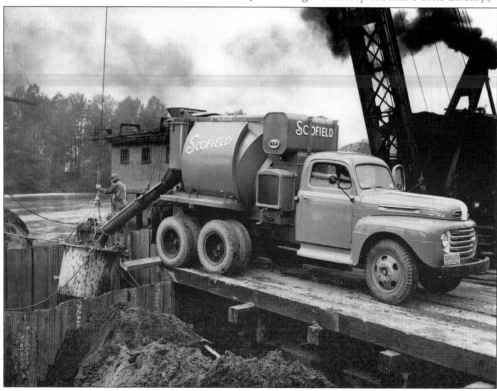

DAY'S TAILOR, 1940s. Hollis Day, an avid horseback rider, is featured taking a jump on the Woodbrook Hunter Trial field on Fort Lewis Military Reservation. Hollis Day was the president of Day's Tailor-D Clothing, Inc., located on South Twenty-ninth Street, just off Pacific Avenue, near where I-5 is now. Founded in 1902 by Eugene Day, Day's became the largest manufacturer of trousers in the Pacific Northwest. At one time, Day's was one of the larger employers in Tacoma, employing nearly 400 people and producing 6,000 pairs of trousers per day. Day's closed its doors to business in the 1978. Hollis Day and his family lived in an English Cotswold cottage, built in 1922 of Wilkeson sandstone, at 11430 Gravelly Lake Drive. (Above courtesy Cyrus Happy III Collection; below courtesy Tacoma Public Library.)

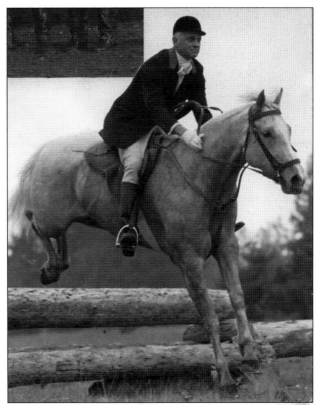

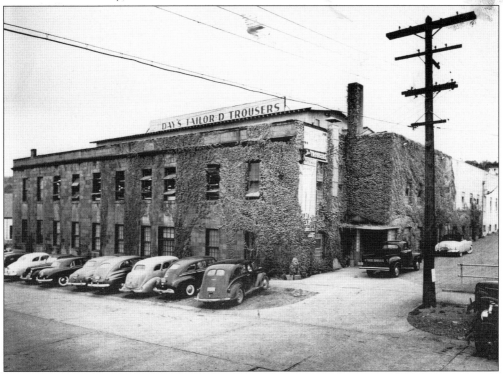

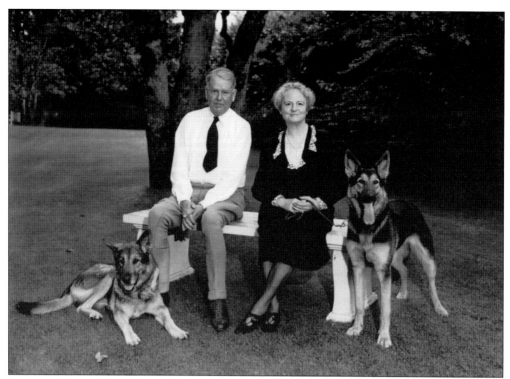

KEYES IN LAKES DISTRICT. Wayne W. Keyes and his wife, Bernice, are shown sitting in their beautiful garden on Gravelly Lake Drive with their dogs around 1947. Keyes, an attorney in the Rust Building in Tacoma, is wearing his English riding breeches, perhaps on his way to a ride on the Fort Lewis prairies. The trees and vegetation illustrate how the prairie landscape changes once one is closer to the lakes (American, Gravelly, and Steilacoom) just north of the WHC. (Both images courtesy Tacoma Public Library.)

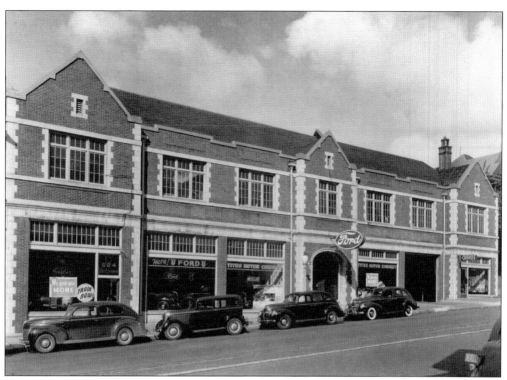

TITUS MOTOR COMPANY. Mrs. L. E. Titus, a founding member of the WHC, was an excellent equestrian rider. She was married to Leon T. Titus, president of Titus Motor Company and Titus Manufacturing Company. Shown in 1939, Titus Motor Company was located at 616–624 Broadway. The "Five Gaited Ride" from Titus's downtown stables was an advertisement for the 1939 WHC horse show. Local businesses sponsored advertisements to help offset the costs of the horse show, with all proceeds going to the care and training of the hounds and the maintenance of the facilities. (Above courtesy Tacoma Public Library; below courtesy Cyrus Happy III Collection.)

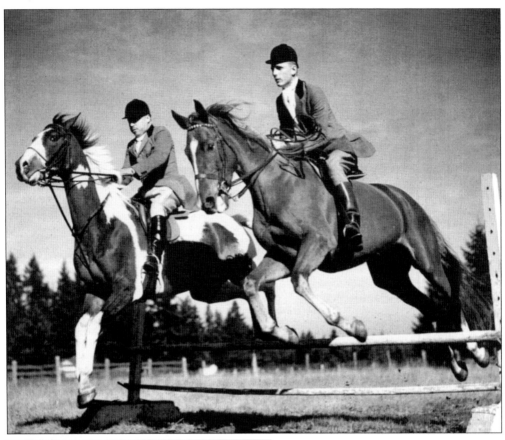

HAPPY AND KENNEDY C. 1948.
Burwood H. Kennedy (left) and Cyrus Happy III are jumping in pairs over a jump in the WHC hunt field. These dashing young men were active with the WHC for many years. Happy, the son of two Stanford-educated parents—attorney Cyrus Happy Sr. and his wife, Marjorie—learned how to ride when he was six from Katherine Rice, a founder of the WHC, on his horse Kay Boy. Kennedy rode hunt seat and was active racing harness horses at the Tacoma Harness Track, the Olympic Riding and Driving Academy, and the Centralia Harness Track. His four-legged companion of choice was the Battling Kid. Happy is a local historian and was associated with the National Bank of Washington in downtown Tacoma. Kennedy was associated with the Harris Campbell and Gault Food Brokers. (Both images courtesy Tacoma Public Library.)

WAGNER'S AND LAKEWOLD: Corydon Wagner was a very active WHC member for years. He resided with his family for many years at Lakewold, a beautiful estate and garden located on Gravelly Lake, and later he resided at Lake Steilacoom. Lakewold is now open to the public so that they may enjoy the beautiful setting of nature and gardens established by Eulalie Wagner in the Lakewold area. Lakewold was formerly owned by Everett Griggs, a founding WHC member. (Courtesy of Tacoma Public Library.)

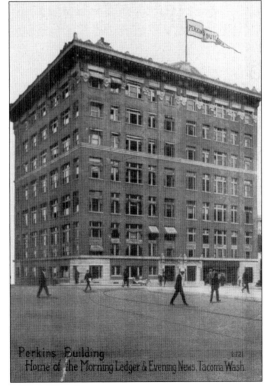

PERKINS BUILDING, C. 1910. Eleanor Perkins was a founding member of the WHC. Her father, Sydney A. Perkins, purchased the *Tacoma News* and the *Daily Ledger* in 1907, adding to his Perkins Press newspaper empire the two biggest newspapers in Tacoma at the time. Perkins was the editor of both Tacoma papers for many years. The building was the first building used for University of Washington, Tacoma. (Courtesy Tacoma Public Library.)

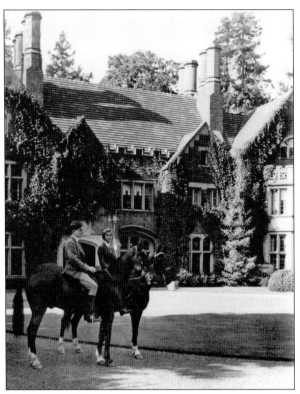

THORNEWOOD ESTATE. Founder Chester Thorne died in 1927; however, his love of horses and hounds was passed to his grandchildren, pictured here at Thornewood Estates. Thorne and Nancy Corse are mounted on their horses, which were kept at the Thornewood Estates Stables. Thorne Corse remembers how kind Thomas Bryan, WHC cofounder, was to him as a child, as well as riding his horse to Woodbrook Riding Academy or WHC for lessons before I-5 was built. (Courtesy Tacoma Public Library.)

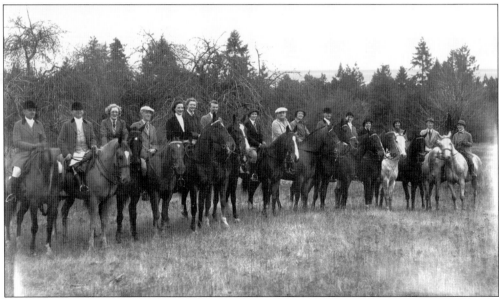

WOODBROOK HUNT CLUB. While many of the founding members came from wealthy Tacoma and surrounding areas, the WHC has always been heavily supported by regular everyday people. The horse is an equalizer and brings everyone to a common standing. Pictured around 1930 are, from left to right, Maj. J. E. Mathews, Hill Hudson, Marguerite Bonnell, Thomas Bryan, Hazel Kenworthy, unidentified, Mrs. Yocum, William Walker, Minot Davis, Pat Erskine, ? Bishop, Iris Bryan, two unidentified, Lee Doud, and unidentified. (Courtesy Tacoma Public Library.)

Three

MASTER OF FOX HOUNDS AND OFFICERS

To the untrained eye, a fox hunt may look like chaos; however, it is quite the contrary. A fox hunt requires organization, planning, and training, with designated officers playing key roles. The Master of Fox Hounds (MFH) is in charge of the overall hunt, including organizing the hunt field and appointing people to the key positions of huntsman and whippers-in. The MFH may choose to have a huntsman, a person in charge of the hounds, or the MFH may choose to play both roles him/herself. The huntsman is in charge of the field (other horseback riders and hounds) and leads anywhere from 20 to 100 mounted riders and a pack of hounds on a 15- to 20-mile pursuit of the quarry, which at WHC has never been a live animal, only a drag scent. The MFH always wears a scarlet-red hunt coat, which is called a pink. MFHs may choose to have someone help them on the hunt and can designate a Joint MFH. The huntsman uses a horn to signal to the hounds and riders different messages. The hounds are trained to respond to the horn. To help the MFH are a huntsman and two or more whippers-in, or whips, to assist during the hunt. They are riders who stay on the periphery and keep the pack from getting spread out and separated. They carry whips that make a loud crack when snapped. These officers have complete right-of-way, and people riding must obey their order or request promptly and willingly. Riders need to stay far enough out of the way so as not to interfere with their work. The MFH is appointed by the board.

The WHC is a nonprofit organization that is open to anyone who is interested, riders and non-riders alike. The WHC is a democratic organization and the least expensive in the United States. The hunt club has many opportunities to volunteer time and ability, including with buildings, grounds, hunt courses, military liaison, housekeeping, and the Hunt Ball.

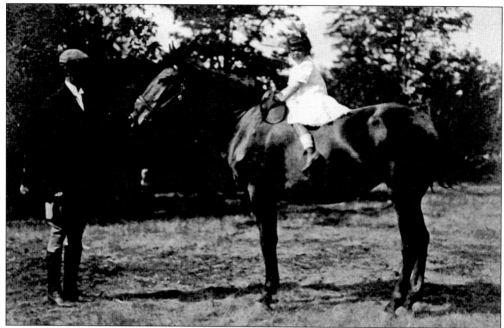

THOMAS H. BRYAN, MFH. The first Master of the Foxhounds (MFH) was Thomas H. Bryan, cofounder of the WHC. Bryan donated the first hounds and served as MFH from 1926 to 1931. Here Bryan holds the reins around 1910 while his daughter, Iris Bryan, age three, is sitting on the horse. Iris, a Stadium High School graduate, grew up to be huntsman or MFH from 1926 to 1951 and worked for Weyerhauser. (Courtesy WHC.)

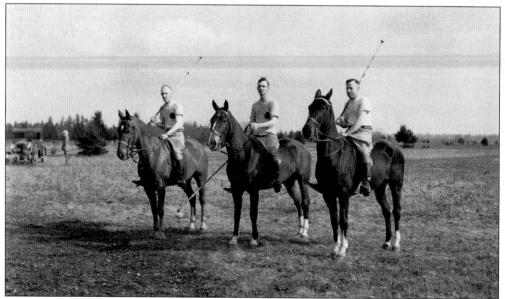

MAJOR MATHEWS, MFH. Cofounder of WHC and owner of the Woodbrook Riding Academy, Maj. J. E. Mathews (center) was the MFH from 1931 to 1932 and again from 1937 to 1941. Mathews donated the land for the WHC in 1929 at Rigney Hill. Pat Erskine (left), president 1934–1935; Major Mathews, MFH; and Burwood Kennedy, MFH 1934–1935, practice nolo on the prairie around 1929, a mix between basketball and polo played on horseback. (Courtesy Tacoma Public Library.)

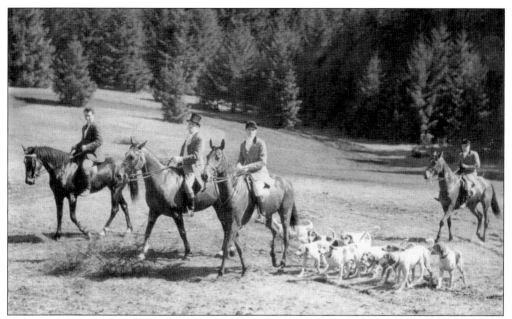

BURWOOD KENNEDY, MFH. Pictured around 1941 is a calm ride across the prairie featuring Art Hannum (left), Don Cameron in the top hat, Iris Bryan, and Burwood Kennedy. Kennedy was MFH from 1934 to 1935. Cameron is wearing a traditional English top hat, the fashion for which the HBC's fur trading posts at Fort Nisqually pursued beaver pelt. These riders are on the land that was the location of Tlithlow, an HBC outpost. (Courtesy Tacoma Public Library.)

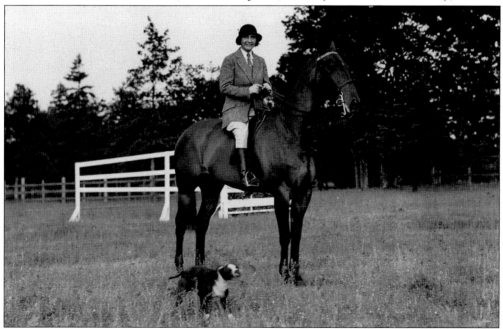

NELSIE DAVIS, MFH. Women have always played an equal role and held key leadership positions at the WHC. Nelsie Davis was the first female MFH at WHC in 1932–1933. Davis is pictured here around 1933 on her horse Flyaway at the Rigney Hill location near the old Pierce County Airport, now McChord Air Force Base. (Courtesy Tacoma Public Library.)

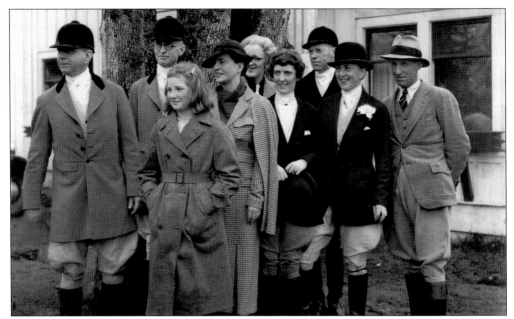

HILL HUDSON, MFH. This 1936 picture was taken at the second location of the WHC on Rigney Hill next to the Pierce County Airport. The clubhouse can be seen in the background. Hill Hudson (far left) served as the MFH from 1935 to 1936. Also pictured are, from left to right, Mr. Bishop from Aberdeen (second from left), Marian Ingram, Mrs. Bishop, Marguerite Bonnell, Helen Young, two unidentified, and Pat Erskine. (Courtesy Tacoma Public Library.)

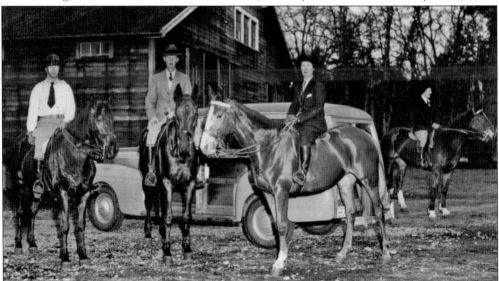

MELLINGER, DOUD, RYAN, AND GILPIN, MFH. This 1940 photograph features, from left to right, Lt. J. J. Mellinger (commander of the Mounted Troop, Home Guard), Lee L. Doud, Marion Gilpin, and Alta Ryan outside the old Woodbrook stable on 150th Street SW, which burned. Doud served as MFH from 1936 to 1937 and was the president of the club from 1929 to 1931 and again from 1933 to 1934. Gilpin served as MFH from 1946 to 1947, as well as from 1954 to 1958, and was president from 1939 to 1941. Ryan was MFH from 1958 to 1961. (Courtesy Tacoma Public Library.)

JOHN DAVIS, MFH, AND DIANE AMOROSO, MFH. John Davis lived in Seattle, and hunted with WHC for many years. He was MFH from 1979 to 1990. He learned to ride as a young boy in Seattle, loved the hounds, and was renowned for his "fish-bowl punch". Diane Amoroso was MFH in the 1980s. Originally from Virginia, Amoroso was a marvelous rider with a beautiful smile. (Courtesy Darlene Woods.)

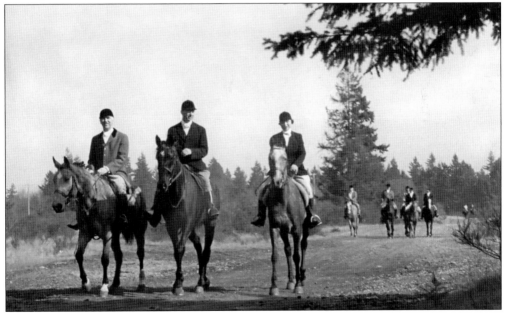

DAN HEWITT, MFH. A descendant of St. Paul and Tacoma Lumber founder Henry Hewitt, Dan Hewitt was an active member of the WHC for many years. Hewitt served as MFH from 1962 to 1972. He kept meticulous records, was an avid horse lover, and was a lot of fun for everyone to be around. Pictured around 1965 are, from left to right, Dan Hewitt, Dr. Peter Piper, and Dr. Ilo Gauditz. (Courtesy Cyrus Happy III Collection.)

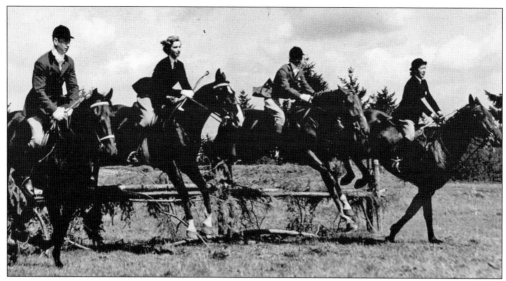

EARL CRAIG, MFH, C. 1950. The Woodbrook Riding Academy was sold by Art Hannum to Earl and Leona Craig in 1946. Craig served as the MFH from 1951 to 1954 and as president from 1951 to 1953. Pictured in this synchronized jump on the Woodbrook Hunter Trial field are, from left to right, Earl Craig, Nancy Creswell, Iris Bryan, and Marion Gilpin. (Courtesy WHC.)

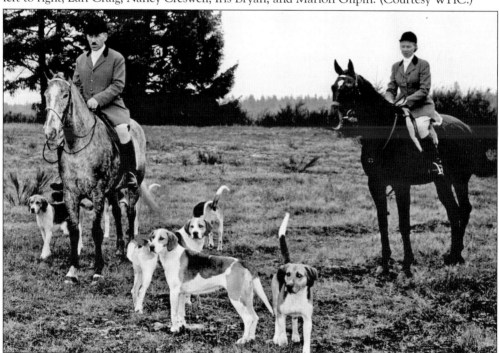

BILLIE JEAN RUST MURPHY, MFH. Al Reizner, whipper-in (left), and Billie Murphy, MFH, are on the prairie south of Tacoma around 1970. Murphy, an accomplished rider, served as MFH from 1973 to 1978. She also served as president from 1971 to 1973. Murphy is named after her grandfather William Rust, who established the Asarco Smelter in the town of Ruston. Reizner was a farrier with considerable talent and ability to work with horses (and people) of all temperaments. (Courtesy WHC.)

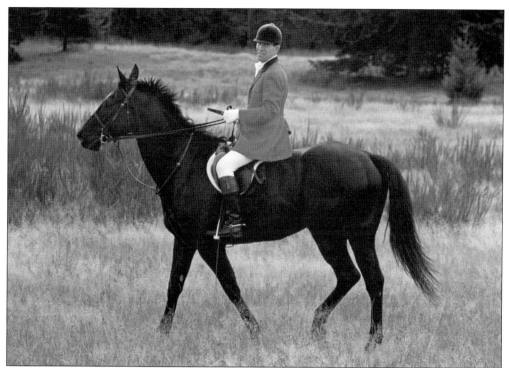

MIKE WAGER, MFH. Mike Wager, Joint MFH, a native Tacoman and graduate of Stadium High School and Washington State University, began riding in his early 30s. He has been active in the WHC since 1977. Wager, a local architect, has served as joint MFH since 1992, and also served as president from 1982 to 1984, and from 1988 to 1990. (Courtesy Poulsen Photography)

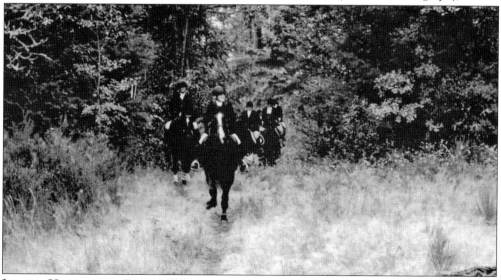

JOANNA HERRIGSTAD, JOINT MFH. Joanna Herrigstad leads a group of riders on a hunt around 2000. She has been a WHC member since 1973, a field master since 1998, and joint MFH since 2003. She started riding horses at the age of eight, hunted at 10, and participated in steeplechases as a teenager in Surrey, England. Herrigstad teaches equitation and is an event judge with the U.S. Equestrian Federation. (Courtesy Poulsen Photography.)

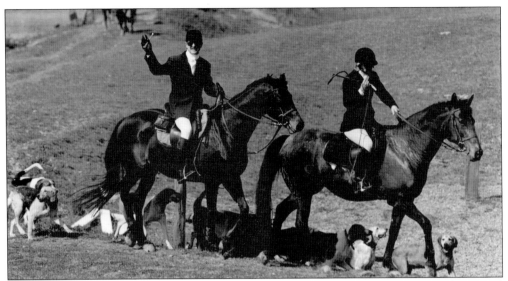

JOHN BROOKS, MFH. A Virginia attorney, John Brooks arrived in Tacoma for a legal case and fell in love with the hunt, the area, and Jean Brooks. He served as MFH from 1990 (when pictured here) until his death in 2004. Brooks (left, riding Ubu) was responsible for ensuring that the WHC Clubhouse was placed on the National Register of Historic Buildings in 1997. He fought to protect the land against the proposed Cross Base Highway, SR-704, which would have destroyed the century-long hunt tradition and much of the last three percent of prairie habitat in the Puget Sound Corridor. (Courtesy Jean Brooks.)

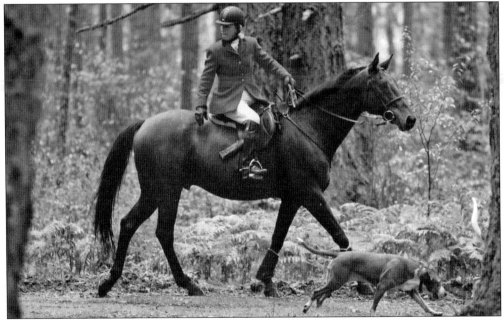

JEAN BROOKS, MFH, DEEP IN THE FOREST WITH HORSE AND HOUNDS. MFH Jean Brooks first sat on a horse when she was two years old. The story is told that her cousins could not get her off the horse, and her family has been wondering how to get her off a horse ever since. Brooks has been the MFH since 2004 and has ridden to the hounds around the world. (Courtesy Poulsen Photography)

Four

Fox, Hounds, and Horses

The fox has eluded the WHC for nearly 100 years. In fact, the WHC has never hunted real foxes; they have always held drag hunts, where a scented burlap bag is dragged over a course. The tradition of the drag hunt was brought over from Ireland by WHC cofounder Thomas H. Bryan, where he trained hounds on large English estates. The main challenge with a drag hunt is to find a scent that interests the hounds and produces plenty of tongue. Over the years, the WHC experimented with different types of scent for the drag, including concoctions of herring, fish oil, and a few drops of asafetida; a wildcat skin; even a live raccoon named Rebecca, who ended up as a pet; before settling on the burlap bag. At first, the drag was laid on foot. Later an old Ford Model T hound-truck was used; unfortunately, it was discovered the hounds were following the scent of the tires and not the drag. Laying the scent on the course with a rope and scented bag from horseback has the best results.

The WHC trains and breeds the American foxhound crossbred, including bloodlines from Orange County, Virginia, and Rockport, Nevada. Hounds are counted by couples or pairs of twos. When Thomas H. Bryan donated the first pack of hounds to the WHC in 1926, he donated 2.5 couples, or five hounds. Over the years, the number of hounds has varied; however, the average has been approximately 15 couples. Many members believe the hounds are the most important feature of the hunt, and hence they are carefully nurtured, trained, and cared for. WHC hires a live-in keeper to take care of them. They are registered with the American Fox Hound Association.

Horses and ponies of all breeds have been used in hunts. The main criterion is the willingness to go, jump, and be well behaved. Matching a horse to a rider's skill and ability is critical because the horse often takes care of the rider.

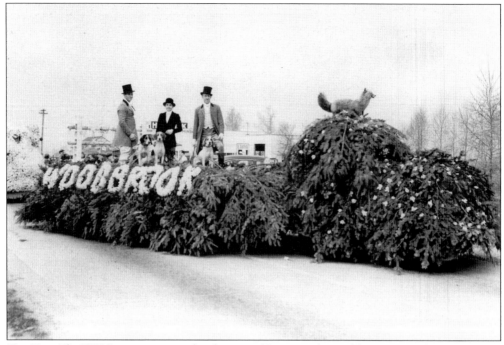

THE FOX. The WHC participates in drag hunts and has never hunted live quarry. The fox on the *c.* 1941 Daffodil Parade Float is the only fox that has ever been seen at the WHC. A drag hunt means a scent is laid on the ground for the hounds to follow. (Courtesy Tacoma Public Library.)

THE DRAG. A burlap bag or rag soaked in a secret concoction is used to lay a scent for the hounds to follow. Pictured around 2007, Allen Amoroso lays the drag using a rag on a rope dragged from horseback on a predetermined course. A good scent initiates "singing" from the hounds. (Courtesy Poulsen Photography.)

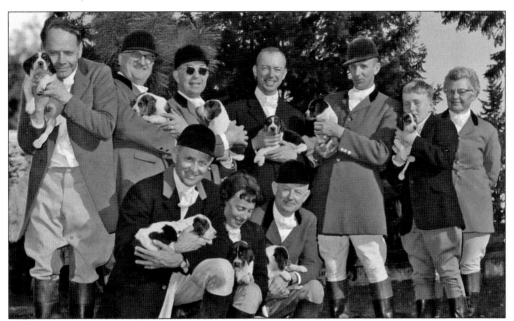

PUPPIES. It is the custom to have an auction for naming the puppies at the annual Hunt Ball. The donations contributed go to the ongoing care of the hounds. Hounds are counted by couples or pairs of twos. Holding 4.5 couples of American crossbred hounds around 1960 are, from left to right, (standing) John Davies (left), Leonard Amoroso, Irving Seldon, Pete Piper, unidentified, Alex Gordon, and Alta Ryan; (kneeling) Hollis Day, Chummy Piper, and Harold Lent. (Courtesy WHC.)

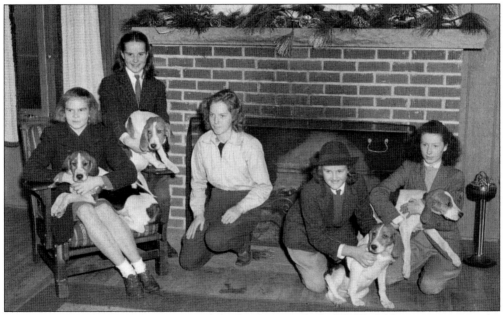

THE NEXT GENERATION. Sitting around the fireplace inside the WHC clubhouse are two couples of American crossbred hounds with five young ladies, officers of the Woodbrook Pony Club. From left to right are Diane Corse, Jean Strong, Wendy Wagner, Nancy Griggs, and Ann Stickney, all descendants of founding members. (Courtesy Tacoma Public Library.)

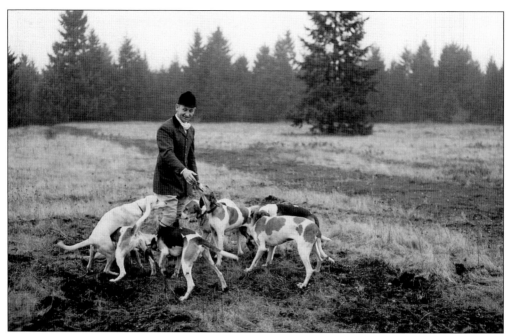

EXERCISING THE HOUNDS. Earl Craig trains hounds around 1952. Hounds are usually trained with another hound, and the two hounds are called a couple or pair. Their collars are leashed together and they are walked until they realize that they must stay with the pack. Early training takes place on foot, usually in small groups, to get them used to the routine. (Courtesy Tacoma Public Library.)

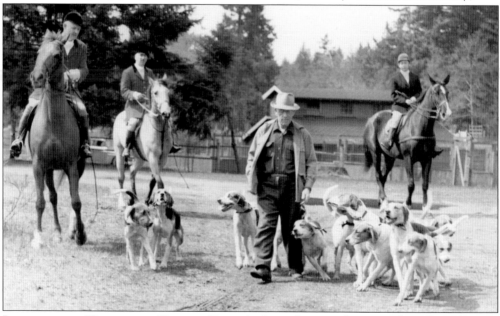

INTRODUCING HOUNDS TO HORSES. Once the hounds are under control on foot, they are introduced to the horse. At this point, the training has the added goal of fitness. A hound begins to hunt between 12 and 18 months of age. From left to right, Harold Lent, Dan Hewitt, Hamilton Dunn (on foot, keeper of the kennel), and Chummy Piper are introducing the hounds to the horses around 1962. The kennels can be seen in the background. (Courtesy WHC.)

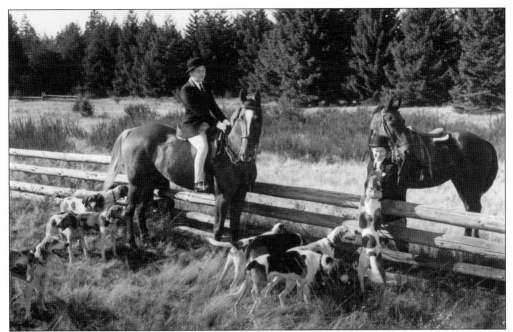

HOUNDS AND HORSES, C. 1953. Alta Ryan (left) and Marion Gilpin are at fence with the hounds. The WHC meets all of the national standards required by the Masters of Foxhounds Association of North America. These standards include a specialized breeding program, and the kennels must meet the qualification of sanitation and space. (Courtesy WHC.)

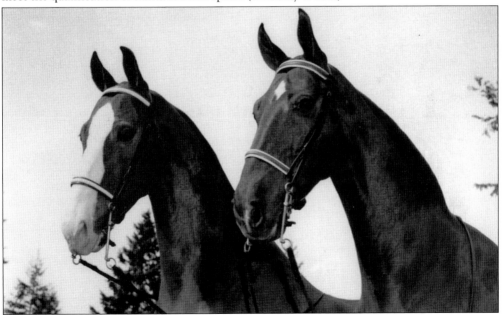

HORSES. Horses, such as those shown here around 1951, can be a great equalizer and unifier across classes and cultures. Horses bring people together. As Winston Churchill once said, "There is something about the outside of a horse that is good for the inside of a man." A good hunt horse is able, willing, conditioned, trained, mannered, and handles a crowd well. (Courtesy Tacoma Public Library.)

HORSES TEACH STUDENTS. Bobby, previously owned by John Davis, Master of Fox Hounds, is approximately 28 years old and is a mainstay of the Brookwood school horse string since Sharon and Larry Michelson purchased the Brookwood Equestrian Center in 1993. In this c. 2002 photograph, Amberose Longrie, age six, is competing on Bobby in the Brookwood Schooling Show. Bobby had eye surgery to restore eyesight in one eye, but is blind in the other. (Courtesy Brookwood Equestrian Center.)

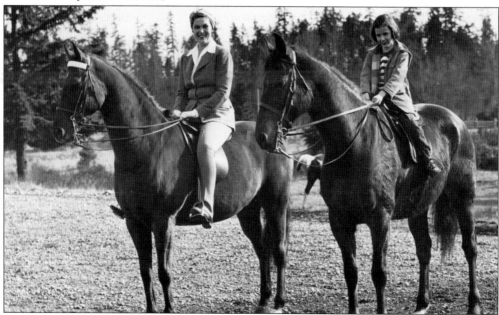

MOTHER AND DAUGHTER. Cecelia Scofield Herreid (left) is on Easter Frolic, and her daughter, Anne Herreid, age 8, is on a Woodbrook school horse, Wee Magic, in 1951. Anne took lessons at Woodbrook Stables in the 1950s and continues to ride. Cecelia Scofield, an active WHC member for years, rode most of her life and continued to be active in non-riding horse competition until she was 89 years old. (Courtesy Anne Herreid Harris.)

Five

TACK AND TOG

Pageantry is part of the hunt tradition carried over from the European continent. The WHC board is eager to maintain the traditions and pageantry of hunting, and have established a formal dress code for hunts. The appropriate WHC dress attire is a black velvet hunt cap, tall black boots, black boot garters, yellow or white breeches, a yellow waistcoat, a black coat with plain black bone buttons, a white stock tie, and a gold safety pin. Beige gloves and spurs with black straps are optional. Women must wear their hair pulled back in a bun with a hairnet.

Men who have been awarded their colors wear a scarlet (pink) coat with black collar, tall black boots with brown tops, and brown boot garters. Women who have been awarded their colors wear a black coat with scarlet collar. Specially made Woodbrook Hunt bronze buttons can only be worn by persons awarded their hunt colors. The only female who is allowed to wear a scarlet coat is the Master of Fox Hounds. Members of the hunt club must earn their colors in the tradition of the sport. To earn their colors, a rider must hunt for at least two years, pass a stringent written test, know the hounds, hunt courses and connecting trails, and serve as a whipper-in.

In addition to the clothes the riders wear, the rider also uses special tack such as an English hunt seat saddle, a breast plate, and a snaffle or Pelham bridle, which are all part of a tradition that is hundreds of years old. Occasionally, sidesaddles are used by the women; however, it is much less common.

The sport of foxhunting is a sport of tradition. To see all the riders on horseback in the scarlet, white, and black, and the hounds all eager for the hunt is really a beautiful sight. Hunt clothing is an important part of hunting. The traditional scarlet coats have their roots in England and Scotland and are based on the Queen's Colours.

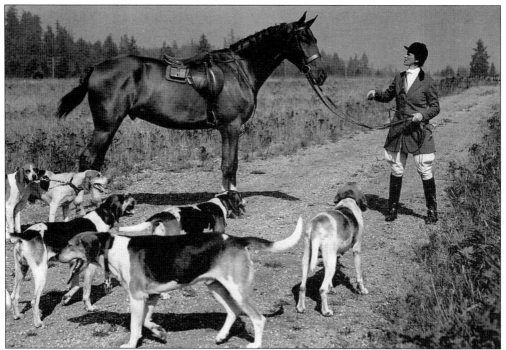

ENGLISH SADDLE AND BRIDLE. A saddlebag, martingale, bridle, and reins adorn a magnificent horse groomed with plaited tail and mane. Iris Bryan is pictured around 1948 in black boots, white breeches, and scarlet (pink) coat with black collar. The hounds are coupled for training with a coupling chain. (Courtesy Tacoma Public Library.)

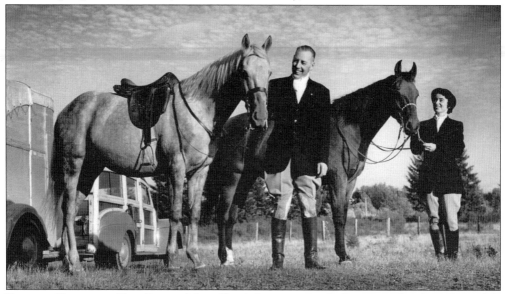

ENGLISH TACK AND TOG. Ray and Joan Kern's horses are tacked up around 1950 with English hunt saddles, martingales, and English bridles. The Kerns are dressed in formal hunt attire: black coat, white shirt, stock tie, gold pin, tall black boots. If horse, hound, or human requires medical assistance in the field, the stock tie and pin can be used as a tourniquet or bandage. Safety helmets were not required until later years. (Courtesy Tacoma Public Library.)

RHODES STORE ADVERTISEMENT. A Tacoma icon, Rhodes Brothers department store was located in downtown Tacoma. Built in 1903 on Eleventh Street and Broadway, Rhodes later had a store in the Lakewood Villa Plaza. The store was a sponsor of the 1936 Woodbrook Hunt Club Annual Horse Show. Equestrian tog could be found on the third floor, with a silk riding shirt costing $3 and cotton shirts just $1.50. (Courtesy Cyrus Happy III Collection.)

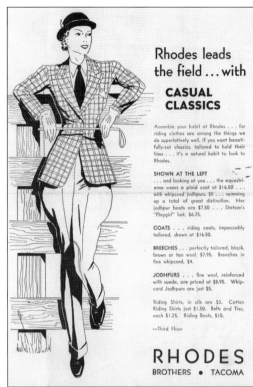

Rhodes leads the field ... with

CASUAL CLASSICS

Assemble your habit at Rhodes . . . for riding clothes are among the things we do superlatively well. If you want beautifully-cut classics, tailored to hold their lines . . . it's a natural habit to look to Rhodes.

SHOWN AT THE LEFT
. . . and looking at you . . . the equestrianne wears a plaid coat at $16.50 . . . with whipcord jodhpurs, $5 . . ., summing up a total of great distinction. Her jodhpur boots are $7.50 . . . Stetson's "Playgirl" hat, $6.75.

COATS . . . riding coats, impeccably tailored, shown at $16.50.

BREECHES . . . perfectly tailored, black, brown or tan wool, $7.95. Breeches in fine whipcord, $4.

JODHPURS . . . fine wool, reinforced with suede, are priced at $8.95. Whipcord Jodhpurs are just $5.

Riding Shirts, in silk are $3. Cotton Riding Shirts just $1.50. Belts and Ties, each $1.25. Riding Boots, $10.

—Third Floor

RHODES
BROTHERS • TACOMA

TOG, C. 1955. Ray Kern (left) is wearing the traditional hunt attire of a gentleman who has received his colors: pink coat with black collar. Dean McDonald wears a "ratcatcher," a darker sport coat or a hacking jacket, shirt, and tie. Marguerite Bonnell Reizner is sporting casual riding attire. Alta Ryan is wearing colors for women, a black coat with red collar. (Courtesy Tacoma Public Library.)

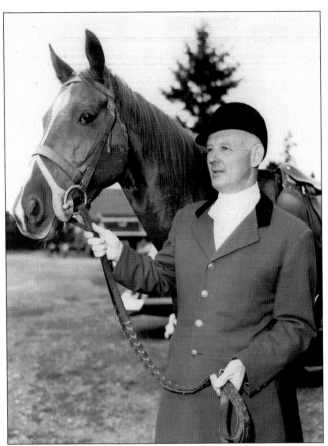

PINK OR SCARLET? Harold Lent, the WHC president in 1953–1954, is wearing traditional hunt colors: a pink (scarlet) coat with black lapels. Historically, hunting clothes were made from red cloth because it was the most visible color. Originally, in England, those taking part wore the royal livery made from scarlet cloth. Some say "pink" is an acceptable term to cover the elderly field coats that have lost their brilliance and bloom through frequent wear and cleaning. Others claim the term "pink" comes from the original tailor for the English royalty whose name was Pink. (Courtesy Tacoma Public Library.)

NUDELMAN BROTHERS. If desired riding apparel could not be found in Tacoma, one could travel to Nudelman Brothers in downtown Seattle or Portland. Nudelman Brothers sponsored the Woodbrook Hunt Club Annual Horse Show in 1938. (Courtesy Cyrus Happy III Collection.)

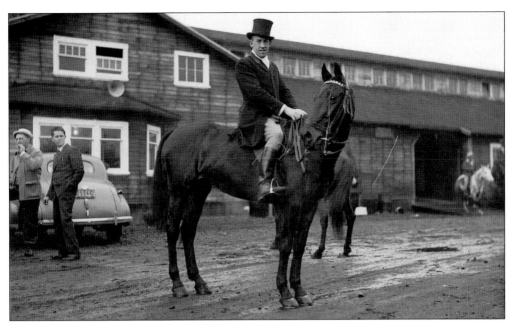

TRADITIONAL TOP HAT. Raw materials (beaver pelts) for the fashionable English top hat were a driver for the Hudson's Bay Company to establish Fort Nisqually on the Nisqually Prairie in 1833. These images, taken nearly a century later, exemplify the traditional English gentlemen's attire on horseback. Don Cameron (above) wears the traditional black coat with black collar, white shirt, stock tie, breeches, tall black boots, and top hat. Below, Cameron is wearing his awarded colors: pink (scarlet) coat with black collar, white shirt and stock tie, yellow breeches, tall black boots, and a top hat. He also is wearing traditional tan gloves and carrying a crop in his left hand. Both of these photographs were taken outside the Woodbrook Riding Academy facilities, which burned down in 1950. (Both images courtesy Tacoma Public Library.)

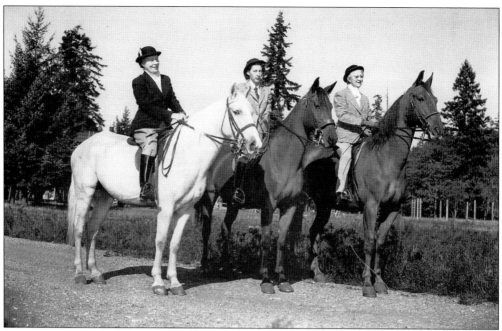

TRIO OF EQUESTRIANS, C. 1948. Estelle Parsons on Honey (right) is wearing formal hunt attire, while Ida Antonsen on Bridget (center) and Ruth Briggs on Bombardier (left) are wearing more casual hacking attire. All three women sport bowling hats, considered stylish at the time. The horses are tacked in English saddles and bridles. (Courtesy Tacoma Public Library.)

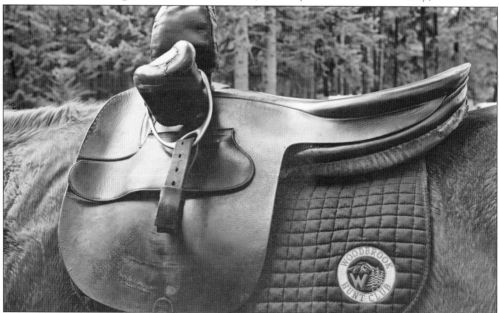

SIDESADDLE. Historically, women rode to the hounds using a sidesaddle. Sidesaddle was first introduced on the Nisqually Prairie by Narcissa Whitman. Both Mrs. Tolmie and Letitia Work Huggins of the HBC are known to have ridden sidesaddle. WHC women who have hunted sidesaddle include the founder's wife, Bunney Mathews, 1926, and Linda Haggermann, 2006. Both women shifted to sidesaddle because of hip conditions. (Courtesy Poulsen Photography.)

WOMEN'S RIDING HABIT. The Victorian era saw more women riding, so dressmakers and tailors specialized in sidesaddle habits. The jacket was a fitted bodice style with a peplum and an extremely long full skirt. Linda Haggermann mounted on an Appaloosa horse is wearing a traditional sidesaddle riding habit in 2006. Women wore traditional top hats in a formal hunt. (Courtesy Poulsen Photography.)

OLYMPIA CAPITOL STEPS, c. 1960. Woodbrook founding member William Walker of Walker Cutting Stone provided much of the building materials for the capitol steps and columns seen here. From left to right, Edwin J. Blake, Billie Jean Rust Murphy, Marion Macdonald, Elizabeth Koons, and Nelson B. Davis, dressed in formal English hunt attire on the capitol steps in Olympia, Washington, hold a silver-plate award from the Woodbrook Hunt Club Annual Horse Show. (Courtesy WHC.)

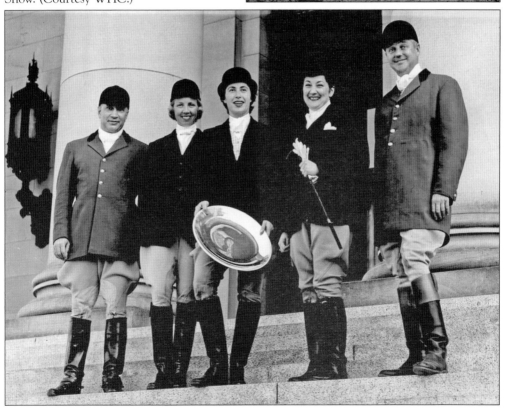

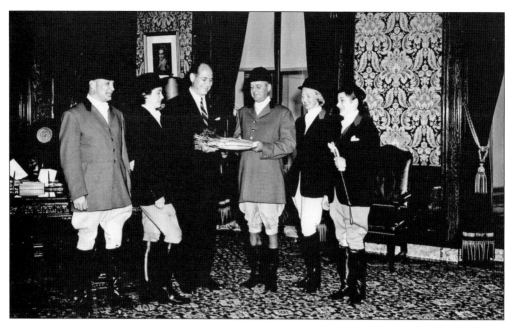

GOVERNOR ROSELLINI. Gov. Albert D. Rosellini, in his office at the state capitol around 1960, presents the Rosellini Trophy laden with carrots to the WHC for the annual horse show. The governor and his family were all horse lovers and rode at WHC. From left to right, Edwin Blake, Marion MacDonald, Governor Rossellini, Nelson B. Davis, Billie Jean Rust Murphy, and Elizabeth Koons. Rossellini, a native Tacoman, was governor from 1956 to 1964. (Courtesy WHC.)

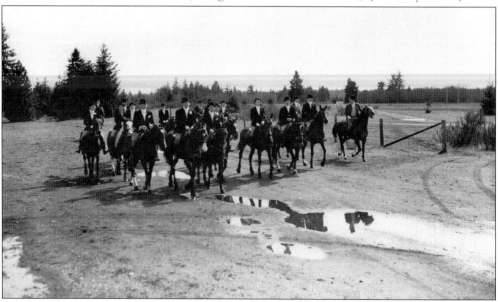

READY TO RIDE. Pageantry is part of the hunt tradition carried over from the European continent. The WHC is eager to maintain the traditions and pageantry of hunting. This 1930s picture captures the pageantry of riders dressed in formal hunt attire mounted on well-groomed horses tacked in English saddles and bridles on the prairies south of Tacoma at the Fort Lewis Military Reservation. This photograph was taken directly in front of the WHC; note that it was taken on open prairie with few trees. (Courtesy Tacoma Public Library.)

Six

HUNT TRADITIONS

The traditional colors of the riders' clothing, horses and tack, the hounds, the music of the hounds and horn, as well as the beautiful setting of the prairie landscape in the shadow of Mount Rainier, all add to the richness of tradition and enjoyment of this sport for participants and spectators. The WHC is blessed by the vision of its founders to be located in close proximity to the Fort Lewis Military Reservation, which has preserved some of the best natural riding conditions in the world.

The hunt itself follows the centuries-old tradition of weekly formal hunts from October through April of each year. During the formal hunt season, special events such as the Opening Hunt, the Blessing of the Hunt, and the New Year's Hunt mark significant milestones celebrated around the world by hunt clubs. Spring and summer months are dedicated to the exercise and training of the hounds, and to building and repairing jump courses, as well as the ongoing coordination with the landowner, Fort Lewis, for the upcoming season's hunts. Year-round the riders and the horses need to be trained and conditioned.

All hunts begin with the preparation of the horse and rider, a stirrup cup toast, and the Master of Fox Hounds (MFH) providing a message to the "field" of riders prior to the first blow of the horn, signaling the beginning of the hunt. The hunt itself covers 15 to 20 miles of countryside and lasts four hours. There are several check-in rest points. The traditional Hunt Breakfast is a much anticipated event following each hunt.

Like all hunt clubs, the social aspects of the group are enjoyed by the members and their family and friends. For nearly a century, the WHC has had a social committee responsible for organizing a variety of social activities, including horse shows, gymkhanas, point-to-points, hunter trials, pony club activities, and the famed Hunt Ball.

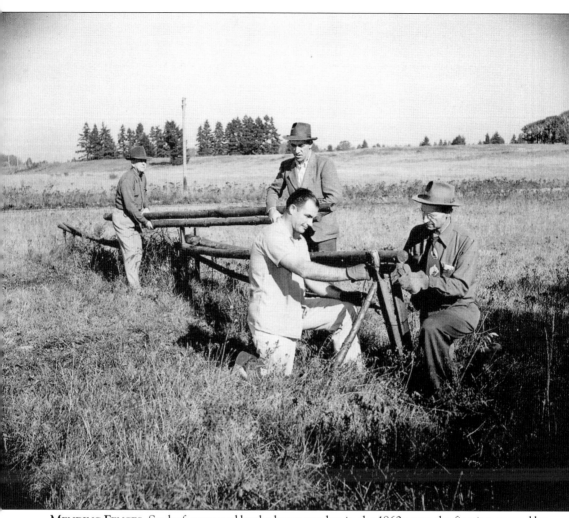

MENDING FENCES. Snake fences used by the homesteaders in the 1860s were the first jumps used by the WHC founders. Work parties include regular maintenance of fences and jumps, and the mowing of paths and fields. These four men, from back to front, unidentified, Al Reizner, Art Hannum, and Lee Doud, repair a fence on the prairie around 1937. (Courtesy Tacoma Public Library.)

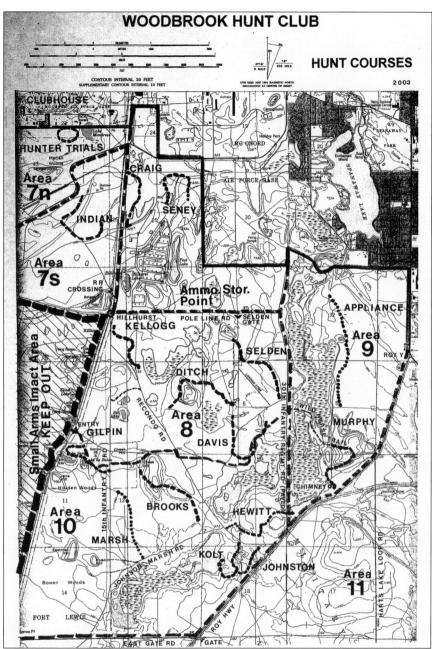

WOODBROOK HUNT COUNTRY, C. 2003. With the permission of the Fort Lewis Military Reservation, the WHC has access to 100,000 acres of prairie, forests, wetlands, creeks, and streams. For the past century, the WHC has ridden to the hounds in the countryside filled with wildlife and waterfowl refuge. Historic activities of the Nisqually tribe, the HBC, and homesteaders all took place here. Access to and existence of these lands is essential to participate in this sport. Many courses are named for hunt club members who have either taken a magnificent tumble or contributed in a significant way to the organization. This map shows some of the hunt courses that have been used for nearly a century, including "Indian," "Wild Horse Trail," and "Chimney." (Courtesy WHC.)

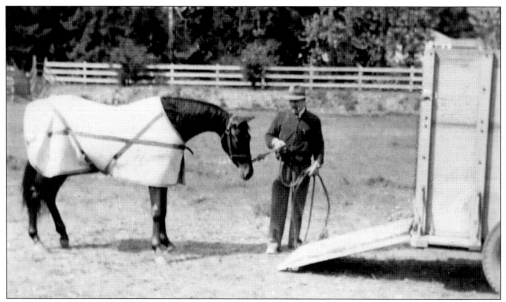

LOADING HORSE TRAILER. Historically, local riders would ride horseback several miles from their homes or barns to a hunt. However, many members came long distances—as far as Portland, Canada, Aberdeen, and Yakima—to ride to the hounds on Fort Lewis. Burwood Kennedy is loading up the Battling Kid into a trailer for a c. 1939 hunt. (Courtesy Cyrus Happy III Collection.)

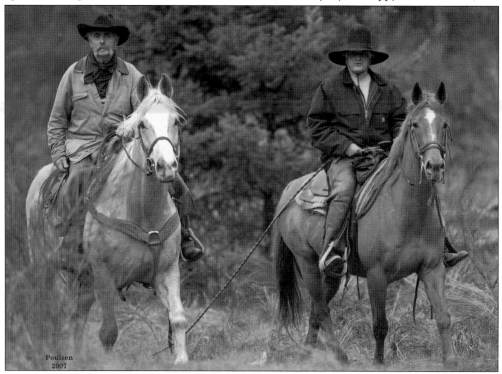

LAYING THE SCENT. Prior to the start of the hunt, the course is dragged with a burlap bag soaked in a special scent for the hounds. Fred Kingwell (left) and Allen Amoroso are laying the drag in 2007. (Courtesy Poulsen Photography.)

PREPARING FOR THE HUNT, C. 1950. Horses not boarded within walking distance are trailered to the WHC clubhouse area, unloaded, cleaned, and tacked up for the hunt. Edwin Blake is mounted and ready to ride. (Courtesy WHC.)

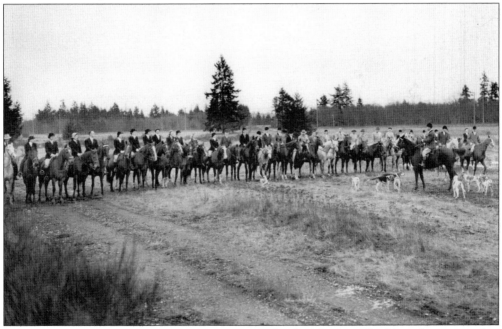

MASTER OF FOX HOUNDS, 1950s. It is customary for the Master of Fox Hounds to give safety instructions to the field of riders prior to beginning the hunt. Earl Craig is talking to the field of riders on the Nisqually Prairie. The MFH is in charge both of planning the hunt and during the hunt itself, assisted by a huntsman, field masters, and whippers-in. (Courtesy Tacoma Public Library.)

HORN SIGNALS START. Lisa Kellogg, MFH, blows the horn signaling the beginning of the hunt to hound, horse, and human around 1978. Different blows of the horn signal different messages to the hounds, which have been carefully trained. (Courtesy *The Seattle Times.*)

HOUNDS OUT. The hounds are released from their kennel around 1950 by Mr. Dunn and gleefully bound out to the huntsman, awaiting their signal to cast out. The hounds are trained to respond to the different blows of the horn when they begin training as a pup at eight months of age. (Courtesy WHC.)

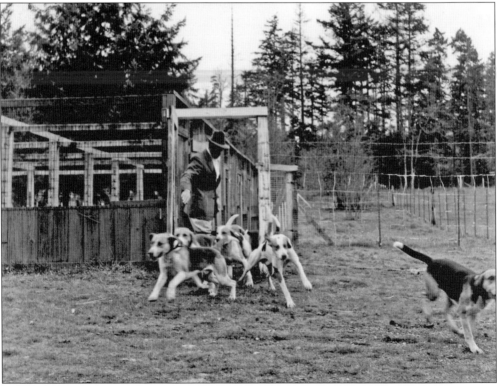

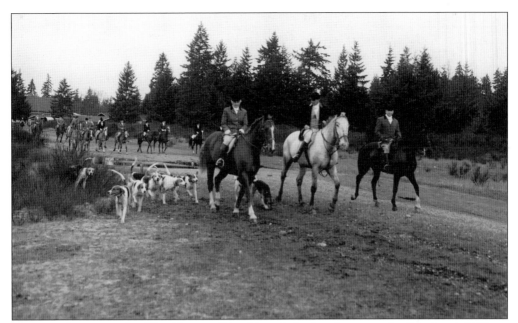

MOVING OUT, C. 1950. The Master of Fox Hounds leads riders onto the Fort Lewis Military Reservation, where the drag has been laid. The 20-mile course crosses the Nisqually Prairie, oak groves, and fir forests. The WHC clubhouse can be seen in the background, as can the Woodbrook stables, barn, and indoor arena. The front three riders are, from left to right, Alta Ryan, Master of Fox Hounds, Budd Dugan, and Dr. Peter Piper. (Courtesy WHC.)

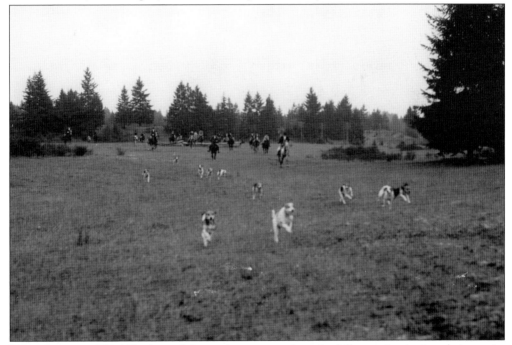

FULL CRY, C. 1950. The hounds have the scent and are in full pursuit, singing their music, followed by the field of riders. In the distance, a jump can be seen across the prairie, with some of the riders going over the jump while others are going around it. (Courtesy WHC.)

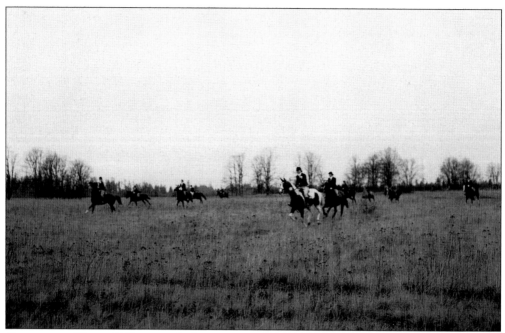

CANTERING. This c. 1941 group of riders is cantering across the prairie in bloom with wildflowers. Oak stands can be seen in the background. Usually there are three flights, or groups of riders, each led by a field master, organized by skill, experience, and ability of horse or rider. (Courtesy Tacoma Public Library.)

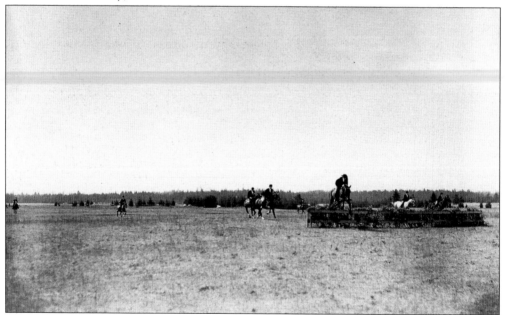

JUMPING OBSTACLES, C. 1941. A hunt averages 15 to 20 miles, and there are usually four or five different courses during a hunt. The club makes and maintains its own jumps along the course. The jumps are logs or other natural barriers. The days of the hunt, as well as the courses, are carefully coordinated with Fort Lewis Range Control, who issues the hunt club a pass to ride on Fort Lewis. (Courtesy Tacoma Public Library.)

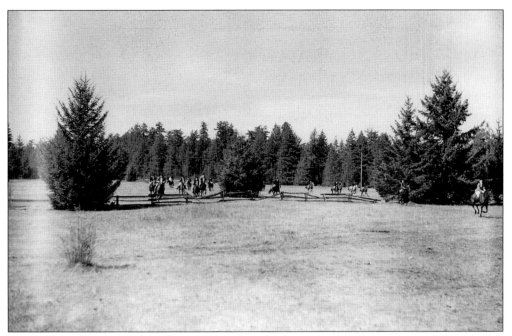

SNAKE RAIL FENCES. When the club began regular hunts during the summer and fall of 1926, snake rail fences from old homestead farms were plentiful on the prairie and served as jumps for the hunt courses. Over the years, the WHC constructed a series of courses. The surest way to get a course named after oneself was to take a spectacular spill over the jump. (Courtesy WHC.)

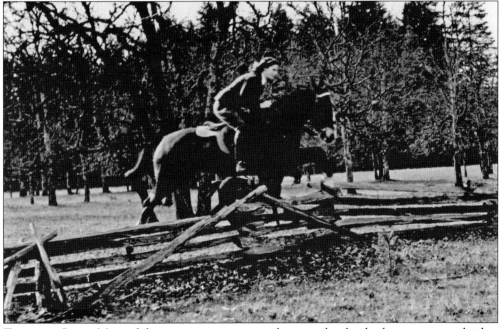

TAKING A JUMP. Most of the jumps are constructed on two levels: the less experienced riders having the choice thereby of a higher or lower jump, or neither. Anita Derby takes a snake rail fence jump around 1935. During the early years of the hunt, helmets were not a requirement. Today they are required for safety. (Courtesy Felicidad Langston Collection.)

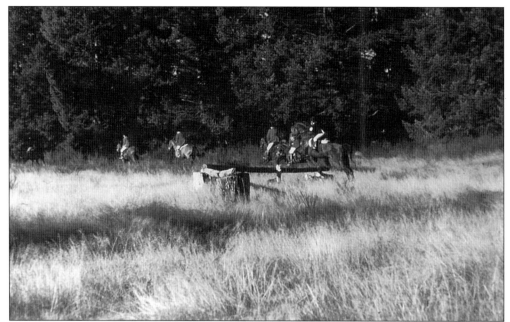

INTO THE WOODS. Riders take a jump on the prairie and head into a fir forest around 1980. Fir trees are considered an invasive plant species on the prairie and a threat to the prairie lands. The Nisqually Indians practiced seasonal burning of the prairie to sustain the habitat for roots, herbs, and prairie grasses. (Courtesy WHC.)

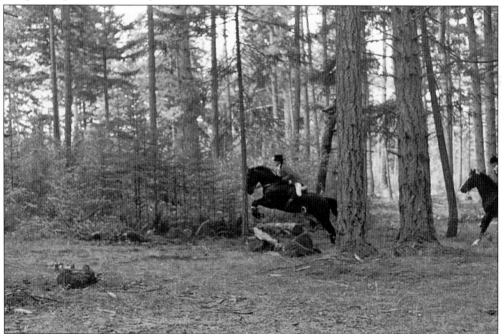

FOREST JUMP. Jumps are built from materials found naturally in the area. This *c.* 1980 jump is made from several fir trees piled together. The tall Douglas fir trees create a majestic sense of space and serenity on the Kellogg course. Mike Wagner, MFH in the 1980 opening hunt, jumps a natural log jump. (Courtesy WHC.)

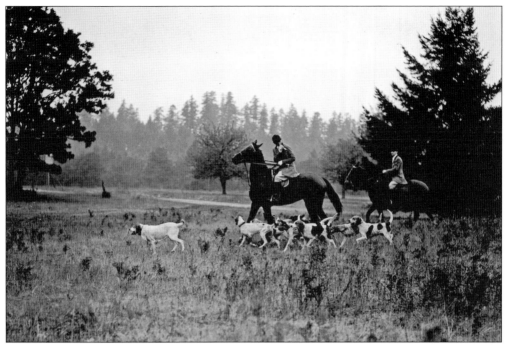

CALLING THE HOUNDS. Iris Bryan, a huntsman and founding member, blows her horn to signal hounds, humans, and horses that it is time to regroup around 1948. (Courtesy Felicidad Langston Collection.)

CARAVAN, C. 1955. At certain points in the hunts, automobile-borne spectators can see the action. A car caravan normally follows the previously announced courses to be hunted. In the past, caravans of horse and buggies and tallyhos followed the hunts to watch at certain predetermined viewpoints. (Courtesy WHC.)

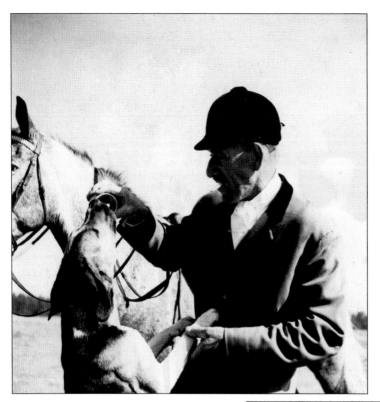

CHECKPOINT. Periodically, horses, hounds, and riders take breaks to rest, get water, and be sure everyone is accounted for. Al Reizner, a huntsman, is giving a hound water from a cup at this c. 1955 checkpoint. (Courtesy WHC.)

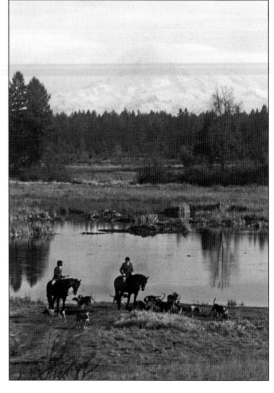

WETLANDS AND MOUNT RAINIER, C. 1980. The geological formations left by the glaciers millions of years ago have left this treasure of special ecosystems with surface water hydrologic links to the ground water. The wetland is habitat for a variety of endangered plant and animal species, including the water howellia and frogs, both of which have been a culturally important resource for the Nisqually tribe. (Courtesy WHC.)

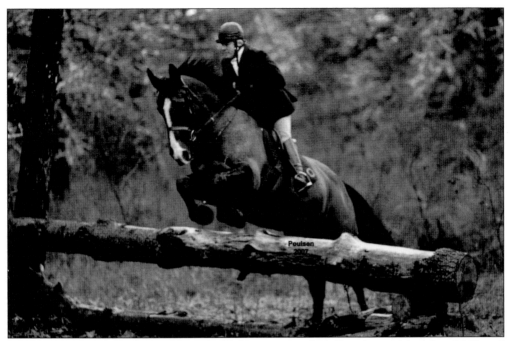

INTERGENERATIONAL. Joanna Herrigstad, a huntsman, riding Guardsman (above) and followed by her granddaughter Paige Herrigstad (below) on Duncan, jumps over a natural log jump. The senior Herrigstad began riding in England at the age of six and has never stopped. She has passed her equestrian enthusiasm on to future generations. Many families participate in equestrian activities together, as horses have always had a way of bridging the generational gap. (Both images courtesy Troutstreaming Photography.)

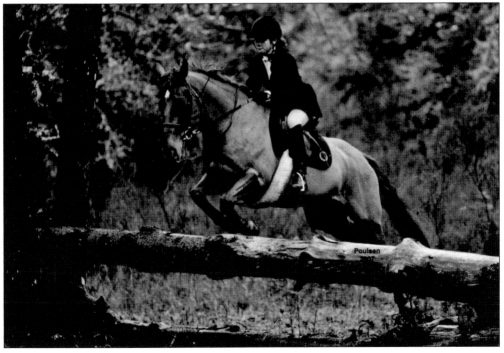

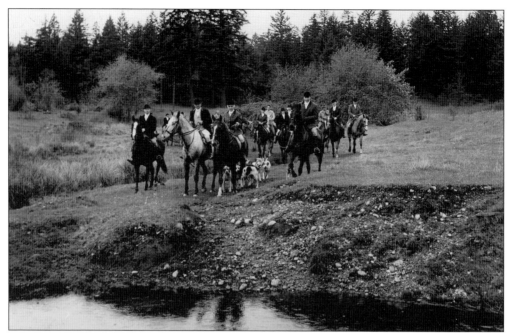

MUCK CREEK. At times, the pace is fast, and at other times, the pace is slower. Oaks, prairie, and fir forests can be seen behind, from left to right, Alta Ryan (MFH), Budd Dugan on Ox, Dr. Peter Piper, Dan Hewitt, Irving Selden, and John Davis with the hounds and others about to cross Muck Creek around 1960. (Courtesy WHC.)

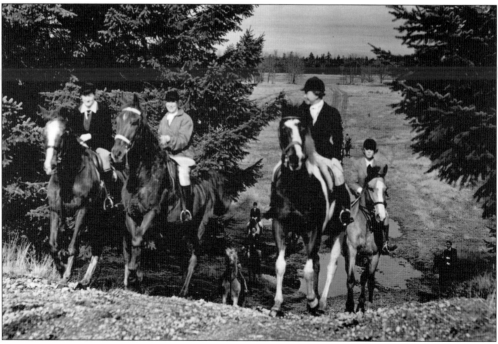

UP A STEEP INCLINE, C. 1950. WHC members go up a rocky incline on the Fort Lewis Military Reservation. From left to right, Karin Woodworth, Earl Craig, and Dr. Ilo Glauditz ride up the hill. The prairie and oak trees without leaves can be seen in the background. (Courtesy WHC.)

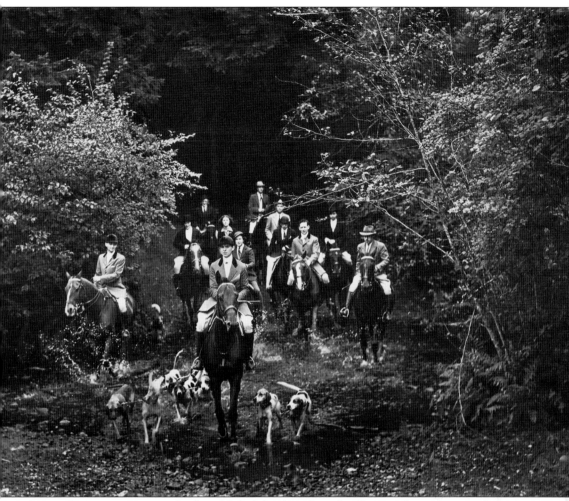

CREEK CROSSING, C. 1933. Stadium High School graduate Iris Bryan, a huntsman, can be seen in the center front, with the hounds around her. The hounds are coupled with chains, a training technique to teach hounds to stay together in a pack. Other riders include Maj. J. E. Mathews (right) and from left to right, Cecelia Scofield, Marguerite Bonnell, Sally Middleton, Lee Doud, Doonalda Mahon, and Burwood Kennedy on the Battling Kid. (Courtesy MOHAI.)

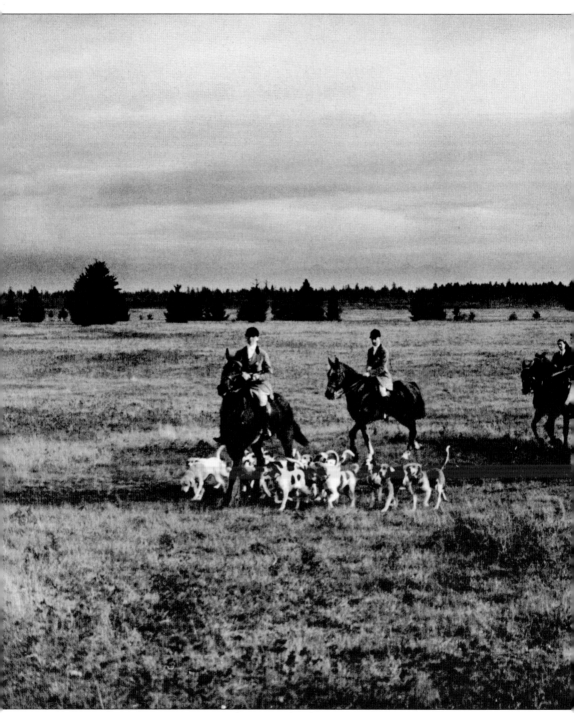

BREAKFAST BOUND. Mount Rainier hovers in the distance as horses, hounds, and riders cross the Nisqually Prairie on their way back for the traditional Hunt Breakfast. They have been cantering, trotting, walking, and jumping for nearly four hours out on the prairie, dashing through forests to the sound of thundering hoofs, the huntsman horn, and the hounds singing. Including the years of training hounds, horses, and people to participate, this centuries-old sport of riding to

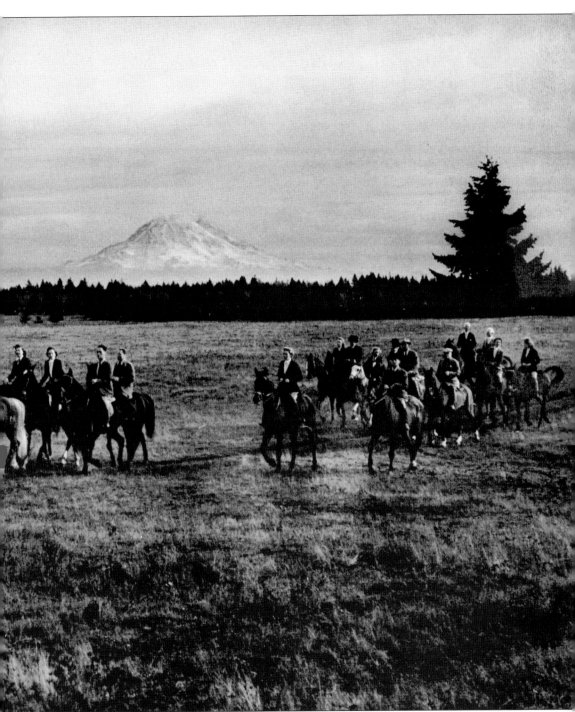

the hounds is addicting, if not exhausting. Pictured around 1940, this photograph includes the following: Iris Bryan on Dare, Herman Friedlander on Topper, Neats Derby on Hi, Jerome Stickney on Raffles, Cyrus ("Jim") Happy III on Ginger, Liz Abeel, Donny Mann, Frost Snyder on Star, Peggy Dolge (wearing a derby hat), Capt. W. C. Proby, Elmer Carlson, A. Burwood Kennedy, Ned Bishop, Donalda Mahon, and Marion Baldwin. (Courtesy WHC.)

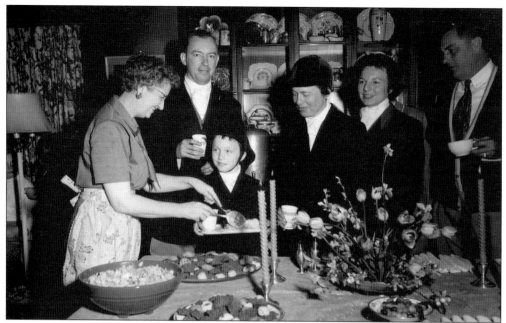

THE HUNT BREAKFAST. One of the fondest memories of many longtime hunt club riders is the traditional Hunt Breakfast. The host/hostess of the breakfast rotates each hunt and stays behind in the clubhouse to prepare the breakfast so everything is ready once the hunt returns. Riders of all generations are served by the hostess. These *c.* 1950 photographs include, above from left to right, unidentified, Dr. Peter Piper, Tootie Piper (child), Chummy Piper, and two unidentified; and below, from left to right, Lottie Meyers of Olympia; Ruth Briggs; Paul Hughes of Bremerton; Norman Baldwin of Sumner; and Mrs. Carlisle Dietrich enjoying a Hunt Breakfast buffet. The Hunt Breakfast may actually be somewhat of a misnomer, as the hunt generally starts at 11:00 a.m. and lasts for nearly four hours, so the food is not served until the late afternoon. Members and their guests are invited to join in the traditional Hunt Breakfast. (Above courtesy WHC; below courtesy Tacoma Public Library.)

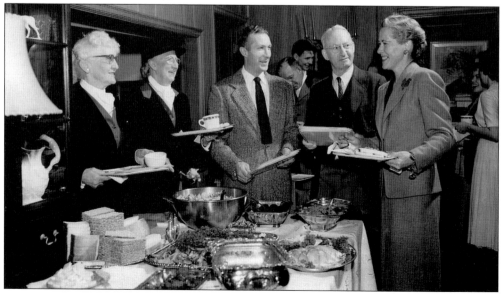

SOCIALIZING WITH FRIENDS. Riding horses to the hounds bridges generational and gender differences. Enjoying a good meal together and swapping stories from the hunt all add to the enjoyment of the day. The younger generation (above) smiles while enjoying a much deserved meal after riding for nearly four hours. Socializing is not contained to the inside of the clubhouse; below, kneeling from left to right, Harold Lent, Marie Palin, John Volk, Martha Palin, Ruby Lacrosse, and, standing in the background, Rip Collins and Claire Reisinger enjoy a campfire in this *c.* 1950 photograph. (Courtesy Tacoma Public Library.)

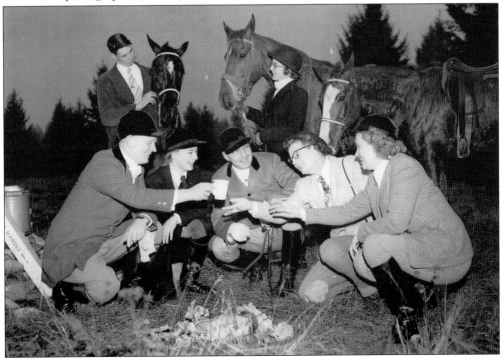

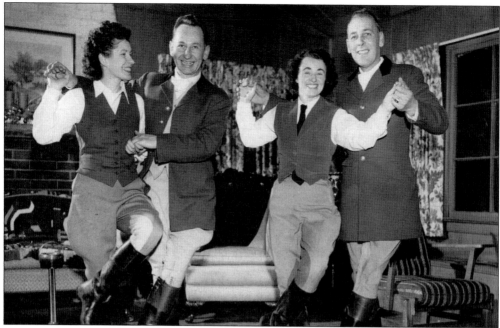

IRISH JIG. Earl Craig, Master of Foxhounds, (left) and his wife, Leona Craig, kick up their heels with Joan and Ray Kern, owners of Freelance Farms, to celebrate the New Year in 1953. The Craigs purchased Woodbrook Riding Academy in 1946 and suffered through the catastrophic fire of the stable and arena in 1950. (Courtesy Tacoma Public Library.)

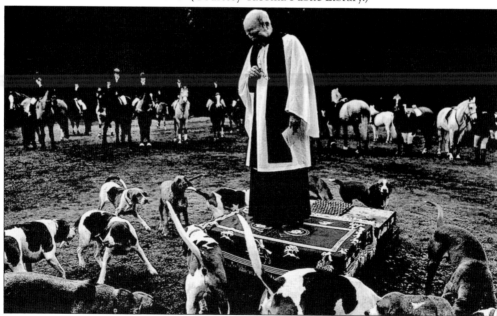

BLESSING OF THE HUNT. The custom of blessing the hunt on or near St. Hubert's Day (November 3) has survived since early medieval times. Rev. Barclay Stanton Jr. is blessing the hounds and the hunt around 2001. The reverend found he had to stand on a mounting block because the hounds were staining his garb while marking their territory. The occasion is accompanied by bagpipes, another hunt tradition. (Courtesy Dean J. Koepfler, *News Tribune*, Tacoma.)

Woodbrook Hunt Club Ball Saturday Evening

Keen Interest Shown in Affair to Be Given at the Country Club; Many Dinner Parties Being Arranged to Precede Dance

HUNT BALL. The Hunt Ball made frequent headlines in the society pages of the *Tacoma Times*, *Tacoma Ledger*, and the *Seattle Post-Intelligencer*. Despite the fact that the nation was suffering a depression, the readership were eager to read about the social events of the area. In the 1930s, more than 500 invitations were mailed out for the event held at the Tacoma Country Club. Twelve-piece orchestras were hired to provide music, and dinners were hosted at private homes prior to the functions. Below is an invitation to the 1988 Woodbrook Hunt Ball. Tradition dictates formal dress of pink (scarlet) tails or black tuxedo, with a top coat, top hat, and white gloves for the gentlemen and black, full-length, formal gowns for women. (Courtesy WHC.)

The Joint Masters
and the
Board of Trustees of the Woodbrook Hunt Club

cordially invite you to a

Hunt Ball

on November 5th, 1988
7:00 p.m. - 1:00 a.m.
at Oakbrook Country Club

• Fifty-five dollars per person •

RSVP

Dress: Formal
Scarlet if Convenient

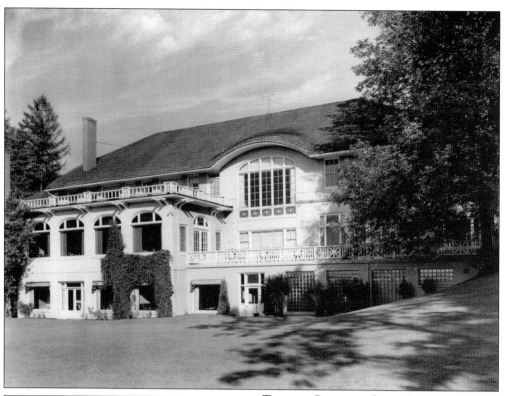

TACOMA COUNTRY CLUB. Prior to being burned to the ground in the 1960s, the Tacoma Country Club was the favorite venue for the Woodbrook Hunt Ball. Early members of the WHC were also associated with the Tacoma Country Club stables, as Maj. J. E. Mathews rented the barn along with Capt. W. C. Proby to develop a riding academy clientele prior to moving in 1925 to Eighty-seventh Street and Union Avenue (South Tacoma Way) around 1930. (Courtesy Tacoma Public Library.)

HORN TRADITION. Ebo Stromeyer, MFH in Canada, Fraser Valley Hunt Club, is wearing his pink (scarlet) tails while blowing a deer horn at the 1995 Woodbrook Hunt Club Hunt Ball. Horn-blowing and whip-cracking contests are traditions of the Hunt Ball. (Courtesy WHC.)

Seven

WHERE IS WOODBROOK?

Maj. J. E. Mathews and Thomas H. Bryan had a clear vision of what it would take to ensure a thriving hunt club: access to open landscape; accessibility for people; and support facilities for the horses, hounds, and people. The WHC has had several homes on the prairie prior to finding its permanent home. Although the WHC was formed in 1926, it was not until 1929 that it had its own clubhouse; prior to that time, they used the riding academy as the clubhouse.

When the WHC was established in 1926, it was established in association with Captain Proby's Riding Academy, located on South Eighty-seventh Street and Union Avenue. A poor working relationship with Captain Proby, combined with the pressures of urbanization, pushed Major Mathews to purchase two acres on Rigney Hill next to the Pierce County Airport. He purchased Captain Proby's Riding Academy stable and moved it in 20-foot sections, reconstructed it, and renamed it the Maj. Mathews Woodbrook Riding Academy.

In 1938, the federal government converted the Pierce County Airport to McChord Air Force Base and expanded the runway. This expansion impacted the Woodbrook Riding Academy and Hunt Club, resulting in a sudden move once again. This time, Major Mathews was able to locate a perfect setting facing the prairie and directly abutting thousands of acres on Fort Lewis. A new arena, barn, and clubhouse were built at this site in 1938.

Tragedy struck in 1950 when the Woodbrook Riding Academy lost the covered arena and stables, along with nine horses, to fire. Despite this setback, the owners at the time, Earl and Leona Craig, built a new barn. They purchased Seattle's Olympic Riding and Driving Academy Arena (now Jackson Park Golf Course) and brought the arena to Tacoma section by section, which became the new Woodbrook Riding Academy Arena.

Over time, the support facilities have changed ownerships and names, there have been fires, and they have rebuilt and made improvements. However, the basic facilities have remained the same since the vision and inception of Major Mathews and T. H. Bryan.

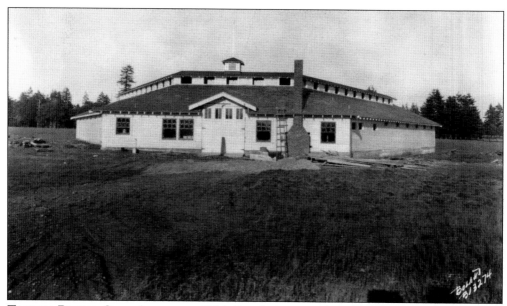

TACOMA RIDING CLUB ARENA, C. 1924. Population growth in Tacoma pushed the Tacoma Riding Club to move from its original location on Twelfth and G Street to a new location on South Eighty-fourth Street and Union Avenue. The Tacoma Riding Club arena had seating for 600, which was leased to Captain Proby's Riding Academy. The academy was associated with the Woodbrook Hunt Club and Polo Team at that time. These stables were later owned by Glenn Betts in the 1940–1950s. (Courtesy Tacoma Public Library.)

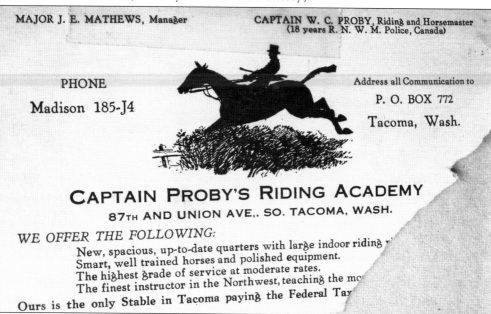

MAJOR J. E. MATHEWS, Manager CAPTAIN W. C. PROBY, Riding and Horsemaster
(18 years R. N. W. M. Police, Canada)

PHONE

Madison 185-J4

Address all Communication to

P. O. BOX 772

Tacoma, Wash.

CAPTAIN PROBY'S RIDING ACADEMY
87TH AND UNION AVE., SO. TACOMA, WASH.

WE OFFER THE FOLLOWING:
New, spacious, up-to-date quarters with large indoor riding
Smart, well trained horses and polished equipment.
The highest grade of service at moderate rates.
The finest instructor in the Northwest, teaching the mo
Ours is the only Stable in Tacoma paying the Federal Tax

CAPTAIN PROBY'S RIDING ACADEMY ADVERTISEMENT. This was a *c.* 1925 advertisement for Captain Proby's Riding Academy, as well as for the Woodbrook Hunt Club and Polo Team. The top hat, traditional English riding attire and high fashion in England, was made from beaver pelts. The demand for pelts in the 1800s spurred the Hudson's Bay Company to locate to Fort Nisqually on the prairies south of the Tacoma area in 1833. (Courtesy WHC.)

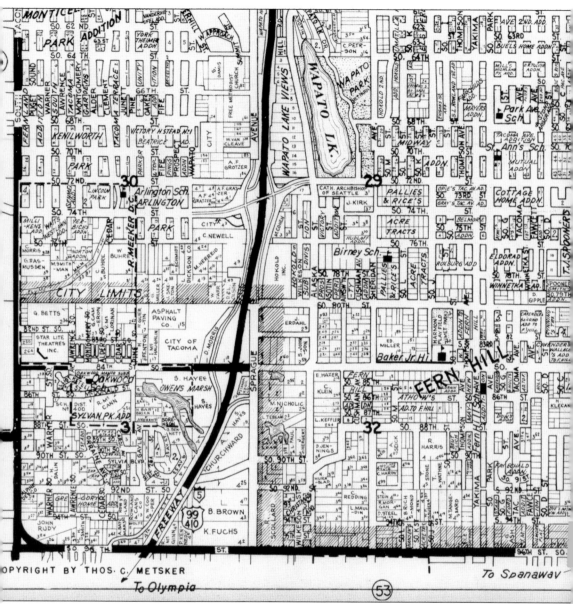

ORIGINAL LOCATION. The Woodbrook Hunt and Polo Club first started out in association with Captain Proby's Riding Academy on 15 acres at Eighty-seventh Street and Union Avenue in South Tacoma, just three blocks south of the Tacoma Riding Academy and across the street from the current B&I store. The location was close enough to town to easily draw customers for riding lessons, while being easily accessible to the prairies south of Tacoma for cross-country rides. The parcel is in the southeast corner of this c. 1965 map, just south of the parcel marked "Star Lite Theatre, Inc." (Courtesy Tacoma Public Library.)

89

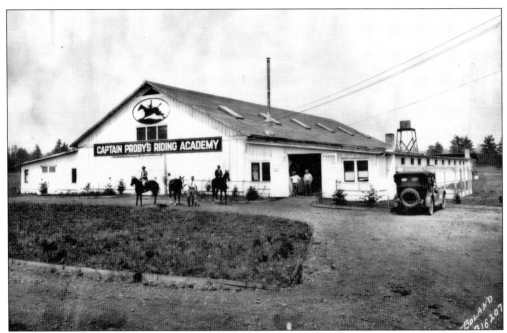

Captain Proby's Riding Academy Stable. This *c.* 1925 vintage photograph is of Captain Proby's Riding Academy, located at Eighty-seventh Street and Union Avenue. Major Mathews trained, schooled, and coached polo at Proby's. (Courtesy WSHS, B16207 and Tacoma Public Library.)

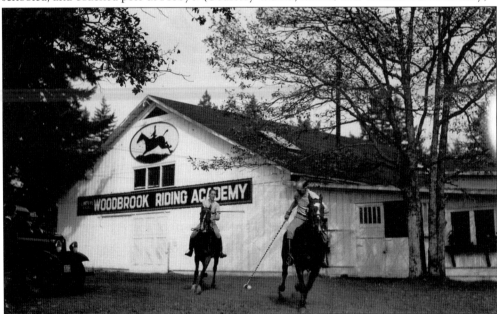

Major Mathews Woodbrook Riding Academy. The partnership between Proby and Mathews did not last. Mathews bought the original Captain Proby's Riding Academy stable and had it moved in two pieces from Eighty-seventh Street and Union Avenue to Rigney Hill next to the Pierce County Airport. This *c.* 1932 image shows the same building with a new logo; note the far left of the sign. The Woodbrook Riding Academy and Hunt Club remained here from 1929 to 1938. (Courtesy Tacoma Public Library.)

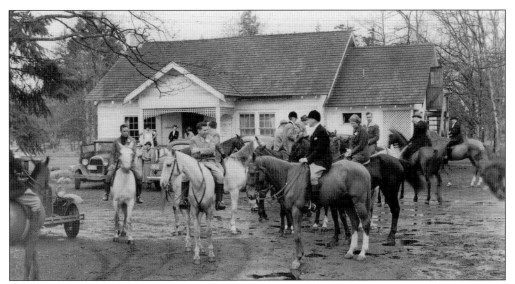

Hunt from Rigney Hill. The WHC clubhouse located on Rigney Hill can be seen in this 1936 photograph. Major Mathews donated an older building to the WHC to use as a clubhouse. Members getting ready to ride with the hounds here include Hill Hudson, Master of the Foxhounds; Iris Bryan, huntsman; Dr. Leroy Goss, president; Burwood Kennedy; Lee Doud; Kathryn Snyder; and Susanne Ingram. (Courtesy Tacoma Public Library.)

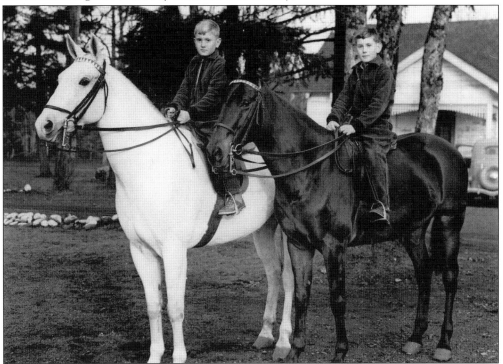

Allen Boys, c. 1935. The original WHC clubhouse on Rigney Hill can be seen behind the two Allen boys. Harold Allen Jr. (right) and Arthur Allen (left), dressed in matching outfits, are on horses tacked in traditional English saddles and bridles. The eldest Allen boy, Harold, became a prominent realtor in Tacoma/Pierce County with Allen Realty. (Courtesy Tacoma Public Library.)

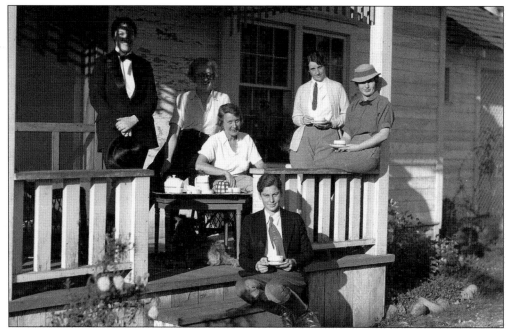

TEA AT RIGNEY HILL. The WHC clubhouse on Rigney Hill had a veranda on the front. These women are having tea after a *c.* 1936 horse show event at the Woodbrook Riding Academy: (from left to right) Cecelia Scofield, Nelsie Davis, Hazel Kenworthy, Bunney Mathews, Kathryn Snyder, and Iris Bryan. (Courtesy Tacoma Public Library.)

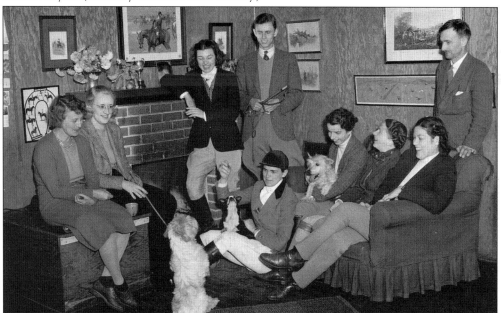

SOCIALIZING INSIDE THE CLUBHOUSE. Young people enjoy socializing inside the WHC clubhouse located on Rigney Hill near the Pierce County Airport around 1936. From left to right are (seated) unidentified, Marguerite Bonnell, Iris Bryan, Dorothy Walker, Bunny Mathews, and Cecelia Scofield Harried; (standing) Sally Middleton, Cyrus Happy III, and Maj. J. E. Mathews. (Courtesy Tacoma Public Library.)

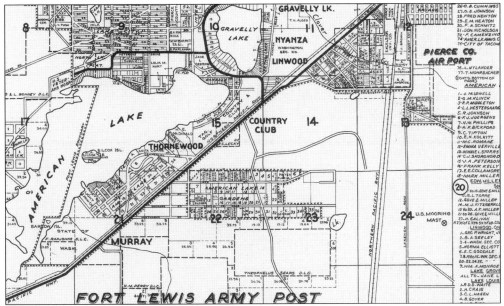

ON THE MOVE. The Woodbrook Riding Academy and Woodbrook Hunt Club facilities moved to a new location in 1929 to a parcel named A. Rigney located west of the Pierce County Airport. In 1938 (just two years after the above image was taken), the federal government decided to site the new McChord Air Force Base at the Pierce County Airport. The new location (pictured below in 1941) is Section 23, Township 19N, Range 2E, as notated by several parcels with J. E. Mathews's name on it. The location next to the prairie was ideal. It also is historically important, adjoining Section 26, the former location of the HBC Tlithlow Outstation; a disputed Thomas Dean land claim; and the location of historic horse races between the Nisqually and Yakama Indians, British, and later homesteaders; it also was the usual hunting and gathering grounds of the Nisqually tribe. (Courtesy Tacoma Public Library.)

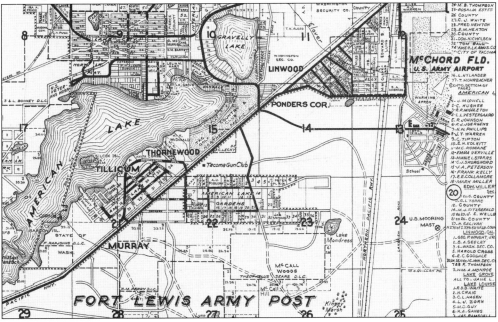

WOODBROOK RIDING ACADEMY ADVERTISEMENT. The *c.* 1938 advertisement demonstrates the link between the Woodbrook Hunt Club and the Woodbrook Riding Academy, owned and operated by Major Mathews. The riding academy offered training, lessons, and horse boarding. Note the lesson special of $1 per person, including horse and instruction. (Courtesy WHC.)

NEW RIDING ACADEMY. The move to the new location in 1938 required a new stable and arena. From the distance can be seen the L-shape design of the building, with the inside arena under the curved roof, including seats for 600 spectators. Stalls for 60 horses were located in the lower set of buildings. The two buildings were connected. (Courtesy WHC.)

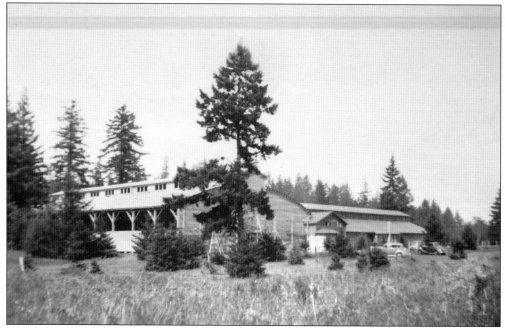

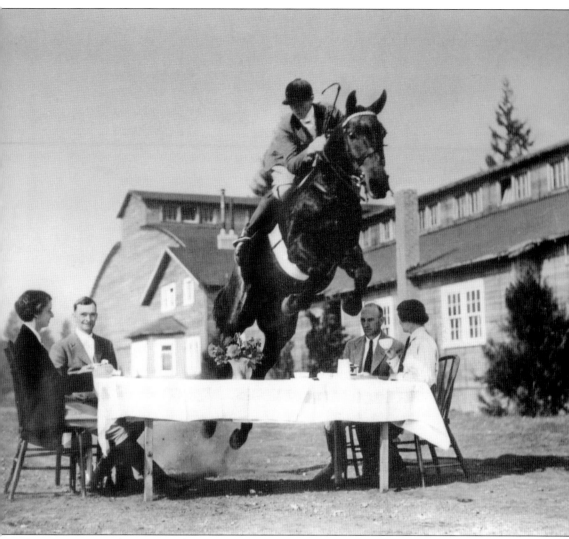

TEA, ANYONE? This spectacular *c.* 1938 photograph appeared on the front cover of the *Seattle Post-Intelligencer* society section. Iris Bryan on Kildaire jumps over a set table. Seated, from left to right, are Dorothy Walker, Major Mathews, Don Cameron, and Bunney Mathews. Note the dust from the horse's back hooves taking off from the ground. The image provides an excellent view of the new stables and arena. (Courtesy WHC.)

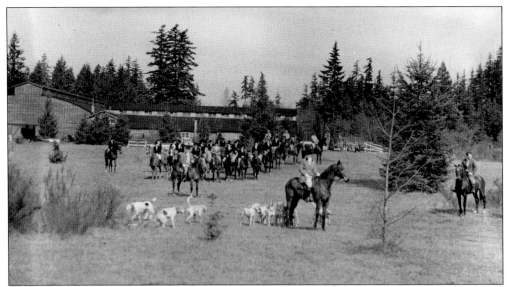

JOINT HUNTS. The WHC traditionally held joint meets with hunt clubs from several areas, including the Lake Oswego Hunt Club, Portland Hunt Club, and Columbia Hunt Club from the following locations: Portland, Oregon; Yakima, Washington; Fraser Valley, Canada; Red Rock, Nevada; and San Diego, California. This c. 1941 scene shows Art Hannum (right), MFH, who purchased the Woodbrook Riding Academy. Iris Bryan is in the center with the hounds. (Courtesy Tacoma Public Library.)

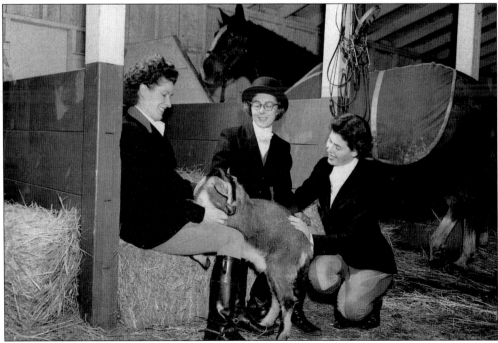

INSIDE STABLES, C. 1939. Three women, from left to right, Leona Craig, Claire Reisinger, and unidentified, sit on bales of hay petting a goat. In the background, a large blanketed horse is in a stall. A bridle is hanging from the post. This is one of only a few pictures of the inside of the stable. (Courtesy Tacoma Public Library.)

THE BATTLING KID. Burwood Kennedy's horse, the Battling Kid, is in the cross-ties inside the Woodbrook Riding Academy Stables in 1939. Kennedy hunted with this horse. When he went to buy the horse, it chased him onto a porch, and he had to be rescued. It took a lot of work to calm him to a manageable state, though he was a real champ. (Courtesy Cyrus Happy III Collection.)

PEDICURE? Julie Craig, daughter of Earl and Leona Craig, who purchased Woodbrook Riding Academy from Art Hannum in 1946, watches Al Reizner shave a horse's hoof in preparation for new shoes in 1949. Horses' hoofs need to be trimmed or shaved every six to eight weeks. (Courtesy Tacoma Public Library.)

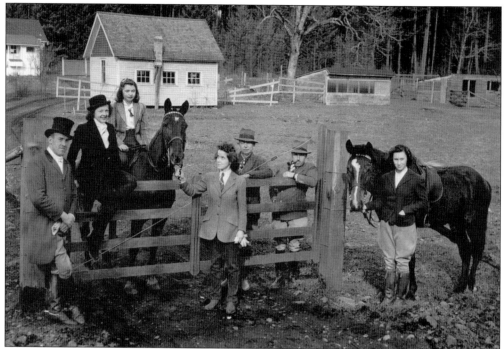

WOODBROOK PASTURE, C. 1941. From left to right, Don Cameron in top hat, Helen Keho Woods, Barbara Hufford, Bibbits Strong, Fred Kenworthy, Burwood Kennedy, and an unidentified girl lean against a gate. Major Mathews's original house can be seen in the background, along with a smaller cottage. Today the buildings are part of Klear Mont Farms, owned by Linda and Steve Pratt. The pasture is part of Brookwood's paddocks, owned by Larry and Sharon Michelson. (Courtesy Tacoma Public Library.)

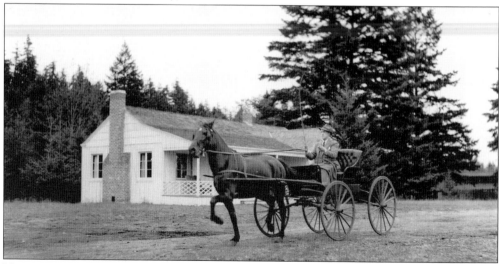

NEW CLUBHOUSE. Major Mathews again donated land to the WHC at the new 150th Street SW location, which necessitated the construction of a new clubhouse. Don Cameron is driving a roadster carriage, pulled by the Battling Kid, in front of the clubhouse, which was completed in 1938. The WHC was listed on the National Register of Historic Places in 1997. (Courtesy Tacoma Public Library.)

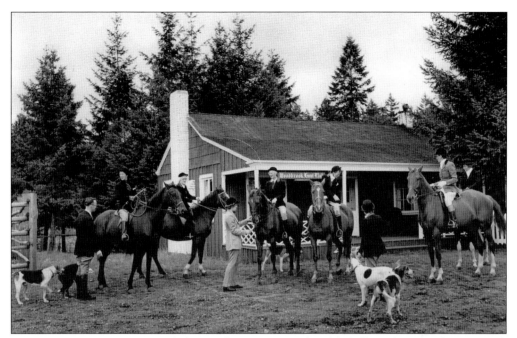

PREPARING TO HUNT. From left to right, Dean Macdonald, Sally Gilpin, Mickey Bonnel, unidentified, Ruth Briggs, Mrs. Clark Gable, unidentified, Iris Bryan, and unidentified prepare for a *c.* 1950 hunt. The riders are in front of the clubhouse in traditional hunt attire. (Courtesy Tacoma Public Library.)

INSIDE THE NEW CLUBHOUSE, 2008. High-beamed ceilings frame a brick fireplace adorned with horse trophies. The clubhouse serves as office space, a meeting room, and home to Hunt Breakfasts, as well as for gatherings celebrating life. (Courtesy Arnold Authement.)

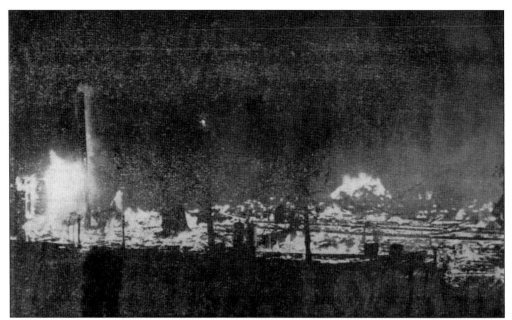

FIRE! Tragedy struck the Woodbrook Riding Academy in 1950 when the roof caught fire during a new roof installation. Despite frantic calls to the fire department, the entire complex was a total loss in a little more than 30 minutes. Owners Earl and Leona Craig were able to save all but nine horses. The surviving horses were scattered across the prairie for a week before they were all rounded up. (Courtesy Pat Toppings.)

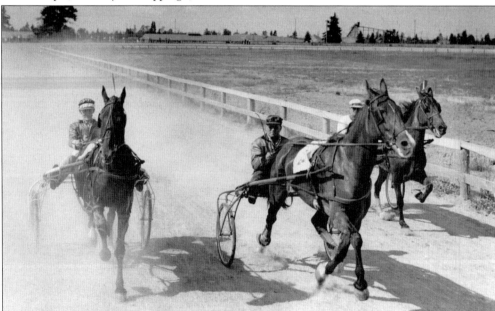

WASHINGTON HARNESS TRACK. The year following the fire, the Woodbrook Riding Academy horses had to be boarded at the Washington Harness Track, also known as old Tacoma Unit, on Old Highway 99 and Bridgeport Way near the current McChord Air Force Base entrance. In the background of this c. 1948 harness-race picture are the stables where the horses were boarded. (Courtesy Tacoma Public Library.)

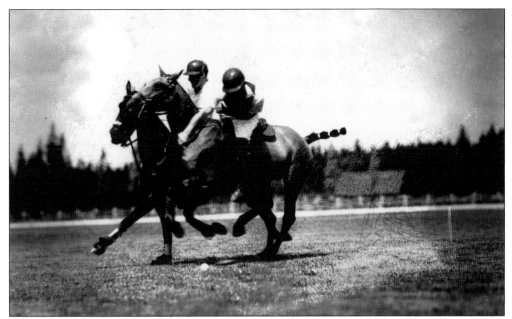

OLYMPIC RIDING AND DRIVING ACADEMY. Woodbrook purchased the Olympic Riding and Driving Academy, located in north Seattle, when the Seattle Parks Department converted the property to the Jackson Park Golf Course. In the distance behind these *c.* 1936 polo players, one can see the indoor arena that was brought down in 20-foot sections to be reused at the Woodbrook Riding Academy in 1951. (Courtesy MOHAI, 86.5.6398.5.)

NEW BARN. Earl and Leona Craig, the Woodbrook Riding Academy's owners, add the last nail in the Woodbrook sign after the tragic fire that struck in 1950. The stable was built separately from the arena to minimize any future losses and has stalls for 45 horses. A "No Smoking In This Stable" sign is a sober reminder of the risk of fire. (Courtesy Tacoma Public Library.)

NEW COVERED ARENA. This mid-1970s image shows the Woodbrook Riding Academy indoor arena, moved by sections from Seattle to Lakewood in the 1950s. Thousands of children of all ages have learned how to ride and have participated in horse shows in this arena during the past 70 years. (Courtesy Sue Wohlford.)

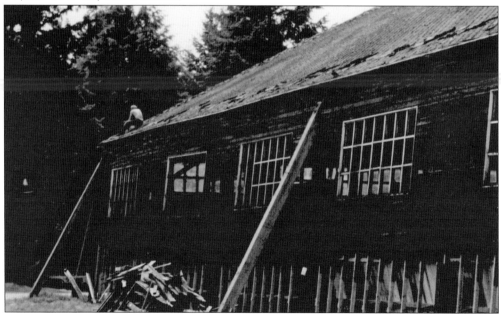

RENEWAL. The aging historic arena, possibly having survived a move from Bremerton Naval Shipyard to Seattle in the 1920s and then from Seattle to Tacoma in the 1950s, was nearly torn down in the early 1980s when Marion Baldwin purchased Woodbrook Riding Stables and changed the name to Brookwood Stables. Repairs proved cheaper than the expensive Pierce County Demolition Permit, and Woodbrook arena was saved again. (Courtesy Brookwood Equestrian Center.)

NEW OUTDOOR ARENA. Larry (right) and Sharon Michelson purchased Brookwood Equestrian Center in 1993. They have invested in many upgrades and repairs of the facility, including a new outdoor arena, for which Michelson is cutting the ceremonial ribbon. In the background, the former house of founder J. E. Mathews can be seen, now called Klear Mont Farm. (Courtesy Brookwood Equestrian Center.)

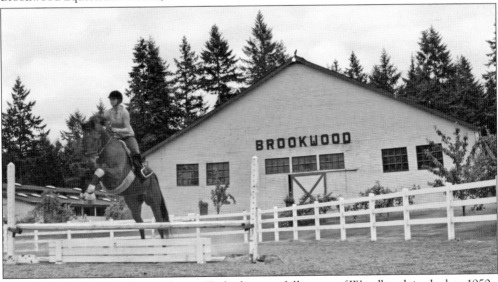

WOODBROOK OR BROOKWOOD? Louise Taylor became full owner of Woodbrook in the late 1950s. She sold the stables to Leon and Sue (Butts) Wohlford of Portland in 1962. Marion Baldwin purchased the facilities in 1981 and changed the name to Brookwood Stables. Larry and Sharon Michelson purchased Brookwood Stables and changed the name to Brookwood Equestrian Center, Inc. in 1993. In the foreground, Kelsey Longrie is on Saber during her lesson with trainer Kimberly Michelson Estada. (Courtesy Arnold Authement.)

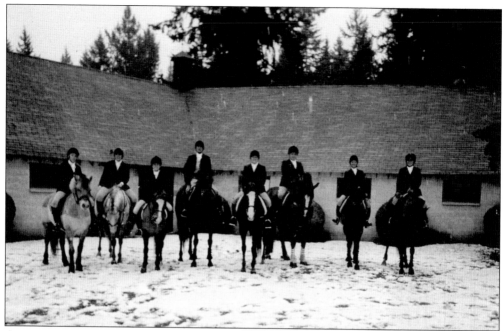

OLD MACDONALD'S PLACE. The Woodbrook Riding Academy leased stables and an arena from Dean MacDonald in the 1970s. The photograph above, taken in 2004, features from left to right, Sarah Glaser on Sol; Michaela Hansen on Taco; Kari Kussman on Simba; Tami Masters on Flyer; Emily Brown on Tilly; Jessica Belcher on Albert; Angela Norrell on Guthrie; and Jennifer Hansen, WHC president 2008–2009, on Dice. In 1970, retired dentist, US Air Force, Lt. Col. William Masters and his family (below) purchased the facilities and changed the name to Horseland Farms and have been active in the WHC as well as equestrian business for over 40 years. Masters founded the McChord Stables in the 1970s, which are still operating today. Masters Family, from left to right, includes Shaina (Humphrey), Christine, Dr. William Masters, Beau, Nicole, Carol, and Tami. (Courtesy of Horseland/Starfire Farms.)

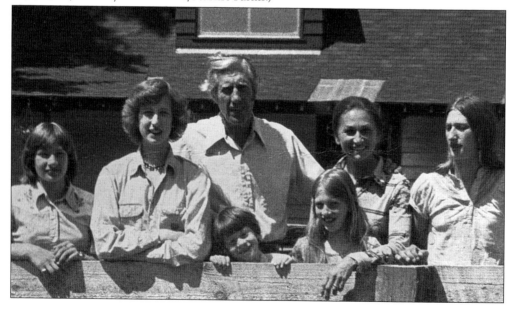

Eight

HORSE PLAY

It takes skill, practice, and a relationship between a horse and rider to successfully ride to the hounds. Horses need to be trained, and riders needs to learn how to ride and care for a horse. Maj. J. E. Mathews and Thomas H. Bryan recognized this critical link from the very beginning with the establishment of the WHC. They had the vision to ensure a strong link with the necessary support facilities.

It takes years for both horse and rider to get to the point to be able to ride to the hounds. Horses have natural ability; however, they also need to be trained. The same can be said of the people who ride the horses. There also is an added dynamic of chemistry between a horse and rider, which requires a true relationship. Over the years, Woodbrook Riding Academy has trained horses and people in basic gaits as well as the advanced disciplines of dressage, jumping, and cross-country events. As the property was divided, more trainers and instructors were drawn to the area. Today there are four training, instructing, and boarding facilities in the WHC vicinity. As could be expected, there have been changes of ownership over the years, with each owner bringing their own special dedication to horse, hound, and rider. Woodbrook Riding Academy had a name change in the 1980s to Brookwood Stables and again in 1993 to Brookwood Equestrian Center, Inc.; however, one theme has remained constant: dedication and devotion to both horse and rider.

To gain competency in this sport, many hours of practice and saddle time are required. Horse shows, games such as gymkhanas, polo, nolo, and trail rides all support this goal. Children can become involved in pony club, summer camps, and holiday camps. Carriage and buggy driving training have been another ongoing sport associated with Woodbrook Riding Academy and Hunt Club. These ongoing activities have resulted in endless hours of fun and learning for riders of all ages and gender. It also helps people of all ages to learn responsibility, horse care, appreciation for the natural environment, and the strong timeless relationship created between horse and rider.

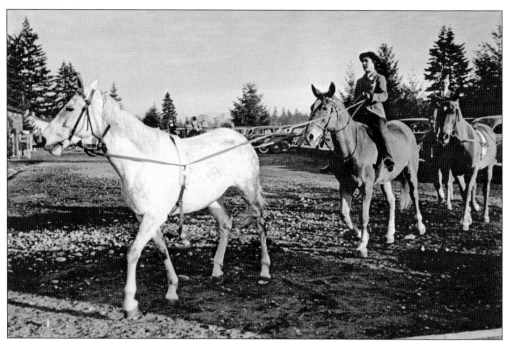

TRAINING TANDEM. One method of training horses to jump is to train the horse tandem style. The trainee horse is in front with long reins held by the rider on a second horse behind. The *c.* 1935 photograph above, taken outside the Woodbrook Riding Academy, features tandem riders: Kathryn Snyder and Cyrus Happy III on Ginger. The *c.* 1935 photograph below illustrates an even more difficult challenge: triple jumping tandem style; Major Mathews is in the middle, and Iris Bryan is on the right. (Both courtesy WHC.)

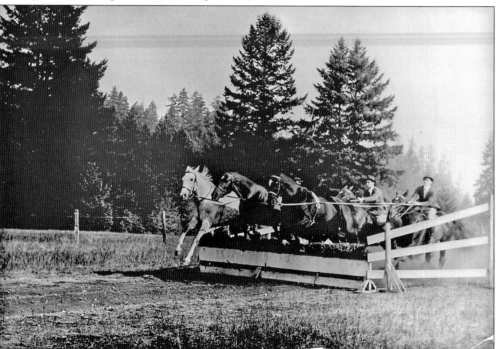

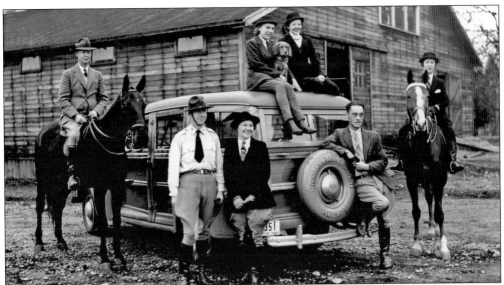

TRANSPORTATION. The Woodbrook Riding Academy station wagon provided transportation from Park Avenue Elementary School, Annie Wright Seminary, and other locations for riding lessons. Pictured around 1940 are, from left to right, Lee L. Doud on Joe Bingen; Lt. J. J. Mellinger, commander of the Mounted Troop, Home Guard; Alta Ryan; Mrs. Art Hannum; Helen Keho; Dr. David Landon of Puyallup; and Sally Gilpin, president of the WHC, on Flashlight. "Woodbrook Riding Academy, LAK 2829" is painted on the rear-mounted spare tire. (Courtesy Tacoma Public Library.)

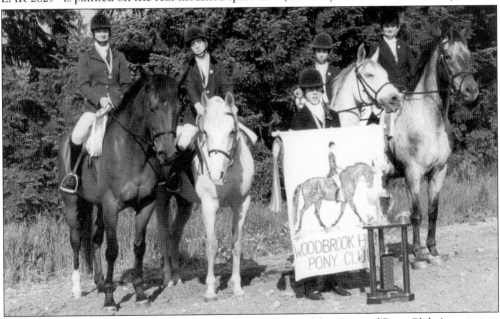

PONY CLUB. The Woodbrook Pony Hunt Club, an affiliate of the National Pony Club Association, was established in 1970 by Iris Bryan, Joan Jackson, Chummy Piper, Billie Murphy, Darlene Wood, Ilo Gauditz, and Ginny Wight. Pony clubs teach children and young adults to work both independently and as part of a team. Pictured around 1987 are, from left to right, Cindy on Gem, Megan on Shurala, Cory on Fresca, and Missy on Ten Speed. The stable manager was Bret. (Courtesy Joan Jackson.)

HALLOWEEN FUN. This *c.* 1965 rider participates in a fun Halloween costume event held inside the Woodbrook Riding Academy arena. Wearing a mask, snorkel, and flippers, and riding bareback make this an extra challenge. This Connemara pony, from Ireland, proved to be one of the most reliable and favorite school ponies. Horses are measured by hands (a hand equals 4 inches); 14.2 hands determines if the equine is a pony or a horse. (Courtesy Sue Wohlford.)

PIERCE COUNTY SHERIFF MOUNTED POSSE, C. 1950. Woodbrook is a Tacoma tradition. It has been the home of the Larriettes, Western Girl's Drill Team; Tacoma Union of Washington Horsemen; Washington State Governor's Guard; and Pierce County Sheriff Mounted Posse. It was also frequently used by Valley Riding Club and other groups. (Courtesy Tacoma Public Library.)

NOLO OR POLO? The J. E. Mathews Woodbrook Riding Academy, located on Rigney Hill next to the old Pierce County Airport, now McChord Air Force Base, provides the background for these women's and men's nolo teams. Nolo, a game popular in the 1930s, is a cross between polo and basketball. Nolo competitions were held between Woodbrook and Fort Lewis, as well as the Olympic Riding and Driving Academy in Seattle. The c. 1935 women's team above includes, from left to right, Iris Bryan (left), Marguerite Bonnell, Catharine Strong, and Bunney Mathews. The c. 1934 men's team featured below includes, from left to right, Bud Kennedy, Pat Erskine, Charles Hyde, and Chauncey Griggs. (Both images courtesy Tacoma Public Library.)

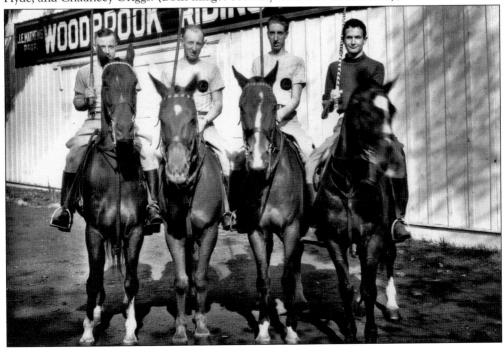

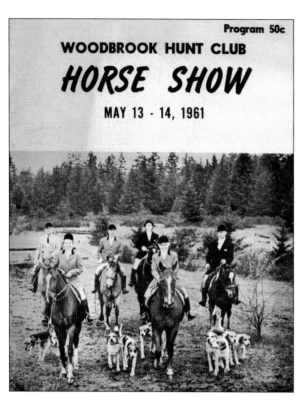

Program 50c

WOODBROOK HUNT CLUB

HORSE SHOW

MAY 13 - 14, 1961

HORSE SHOW, 1961. Woodbrook held annual horse shows, beginning in the 1930s through 1961, inside the Woodbrook Riding Academy covered arena. Annual horse shows provided a mechanism to raise funds for the hounds. (Courtesy Cyrus Happy III Collection.)

COMPETING IN THE ARENA. Linda Piper, riding Christopher Robin, competes in the "10 and under Equitation" class at the *c.* 1961 Woodbrook Hunt Club Annual Horse Show. The three Piper girls, (Karen, Linda, and Suki) hunted regularly. Linda made a career of training and showing hunters and jumpers. In her teens, she rode for Woodbrook Stables and was considered one of the top junior riders on the West Coast. (Courtesy Linda Piper.)

SERIOUS JUMPING, C. 1967. Sue (Butts) Wohlford is jumping Royal Patrick inside the Woodbrook arena. Wohlford began riding when she was six years old at the Highland School of Riding in Portland, fell off, got scared, and did not ride again until she was in seventh grade. She competed and taught riding for many decades. She also sponsored an annual horse show to benefit the U.S. Equestrian Olympic Team. (Courtesy Sue Wohlford.)

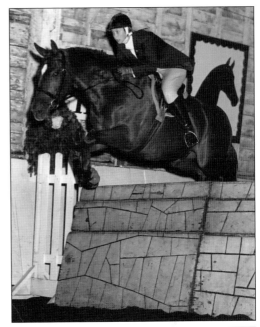

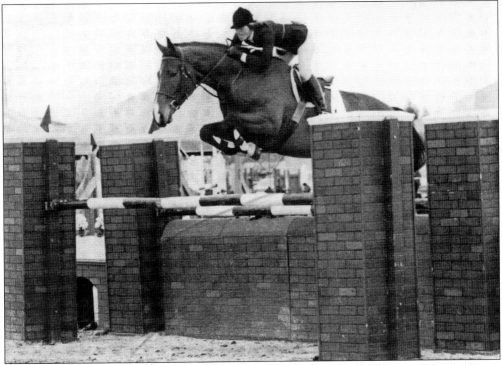

MASTERS AT NATIONAL HORSESHOW. Tami Masters jumps Tacoma South over a 5-foot-high oxer jump in the 1985 Evergreen Classic Horse Show. Tacoma South, a 16.3-hand, Washington-bred Thoroughbred, was owned by Carlo Msters, Horseland Farms. Masters became a WHC member when she was 9 years old in 1968. She received her junior colors when she was 11 and has served as a whip for WHC for many years. Gordy Woods was Masters's trainer. (Courtesy of Horseland/Starfire Farms.)

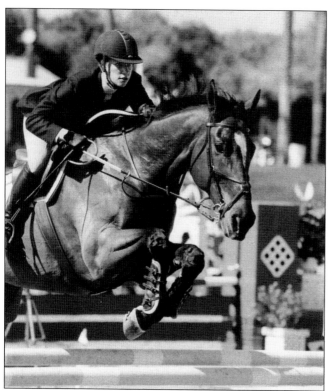

NATIONAL COMPETITION. Woodbrook and the surrounding equestrian facilities have produced many national champions. Kimberly Michelson Estrada, of the Brookwood Equestrian Center, rides Show Session at the c. 2003 Indy Horse National Show in California. Show Session was a Thoroughbred, measuring just over 17.3 hands. (Courtesy Brookwood Equestrian Center.)

HUNTER TRIALS. Beginning in 1962, the hunt club began to sponsor the annual Hunter Trials instead of the annual horse show. The Hunter Trials are held every October in a field on Fort Lewis with many permanent jumps constructed of native materials from the area. The covered platform is a temporary judge's stand. Riders are warming up on the Nisqually Prairie around 1998. (Courtesy Linda Aaron, Prized Images Photo.)

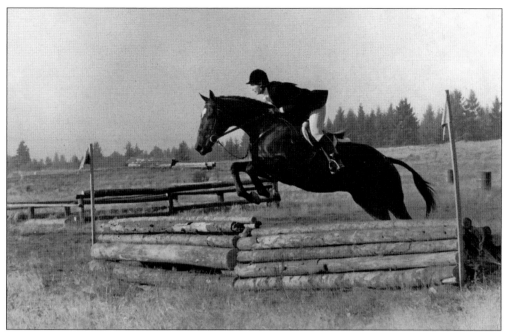

JUMPING AT TRIALS. Sue (Butts) Wohlford, riding Old English around 1965, takes a jump on the WHC Hunter Trial course on Nisqually Prairie, Fort Lewis. Old English won the Grand Prix des Nation jumping at the 1972 Olympics in Aachen, Germany, clearing 6-foot-high jumps. (Courtesy Sue Wohlford.)

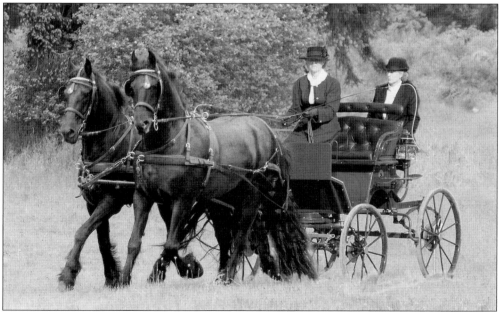

HORSE AND CARRIAGE. Ann Kirk Davis drives her formal Spider phaeton pulled by two Friesian horses, Milagro and Rinse, on the Nisqually Prairie in 2006. Davis is dressed in formal attire—hat, jacket, robe, gloves, and whip. She is the secretary of the American Driving Society. Kirk, a former Lakewood city councilmember, learned to ride at Woodbrook Riding Academy in 1948. (Courtesy Ann Kirk Davis and Horn Fine Art Imaging.)

HORSE TRADING. Buying horses is both an art and a science that goes back centuries. Burwood Kennedy is considering purchasing this horse around 1939. (Courtesy Cyrus Happy III Collection.)

HORSE SHOEING. Al Reizner (right), a WHC member, fashions a horseshoe with his anvil and hammer just outside of the Woodbrook Riding Academy stable door around 1949. Reizner wears a special leather apron for his work and shoes more than 100 horses each month. (Courtesy Tacoma Public Library.)

HORSES HAVE FROGS? Kelsey Longrie, a junior at Stadium High School, picks the hoof of Saber. A horse's hoof has a soft inner cushion called a "frog," which pumps blood back to the heart. Longrie started riding at the age of eight at Brookwood and volunteers at Brookwood Summer Horse Camps, helping young children learn basic care and riding skills. (Courtesy Arnold Authement.)

NEWBORN. The first step of this filly with her mother licking her clean was captured in this photograph. A c. 1965 Woodbrook horse show was stopped so the riders could quietly witness the miracle of birth. This photograph was taken just minutes after the filly was born. (Courtesy Sue Wohlford.)

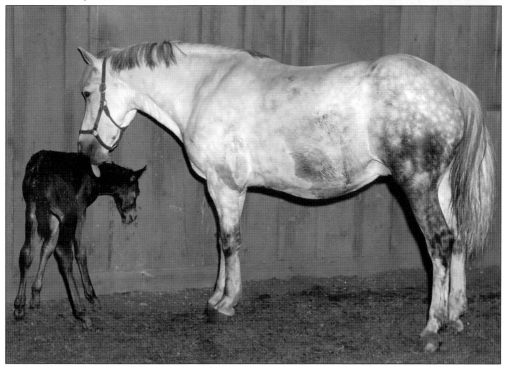

"Ginger"

Ginger is a nice horse
This I must say
For if you try to pat him
He wont run away.

There's one thing Ginger doesn't like
And thats a curb bit
If I tried to use it much
He'd probably have a fit

But there's one thing he does like
And thats his oats
For he likes them as much as we like
Root-beer floats

by Helen Rust

POEM AND SKETCH. Little girls love horses: they dream about horses, they play horses, they draw horses, and some even write poems to horses. Helen Rust, granddaughter of William Rust, the Tacoma Smelter magnate, drew a sketch and wrote a poem about Ginger the horse in 1935. Ginger was a palomino, a light tan horse with a beautiful blond mane and tail, owned by Cyrus ("Jimmy") Happy. (Courtesy Cyrus Happy III Collection.)

HORSE HUGS, 2008. Aurora Authement, 10, hugs her horse, Ryan, and gets a hug back. The bond created between a horse and rider is strong. Authement began riding when she was five years old. She rides competitively on Ryan, her Warmblood/Thoroughbred, who stands 16.2 hands high. (Courtesy Arnold Authement.)

Nine

MILITARY PARTNERSHIP

Fort Lewis and the WHC have shared an interest of open space, personnel, and horses since its inception with Commanding General Alexander as an honorary member. Over the years, many clients and members have military roots. The Washington State National Guard held Brigade Encampments from 1890 to 1904 involving thousands of men and horses near American Lake, just north of where the WHC is today. Among the many units involved in the maneuvers were Troops F and H, 9th U.S. Cavalry, and Troop B, National Guard of Washington. The maneuvers were a great success and created much military interest in the area, resulting in the establishment of Camp Murray, in 1904, as the headquarters for the Washington State National Guard. A local vote in 1917 established Camp Lewis. The 10th Artillery was a horse-drawn artillery unit in the regular army and was stationed at Camp/Fort Lewis.

The Headquarters Troop, 24th Cavalry Division, Troop B, Washington State National Guard and the Woodbrook Riding Academy/WHC had a close partnership and shared interest in equestrian activities and members, including Maj. Everett Griggs, a member of both Troop B and WHC. Together they participated in many activities, including polo, nolo, hunting, and shows. Both Fort Lewis Military Base and McChord Air Force Base had stables on base for military personnel and their families.

By the late 1930s, war had started in Europe, and the peaceful days of the Fort Lewis Reservation were over. All routine riding activities were suspended. The pack of hounds was dispersed to individual families to care for. The riding arena was leased to the government for a box factory, and the clubhouse was used for military housing. Woodbrook riders also became active in the war effort. The Wyoming 115th Cavalry was stationed at Fort Lewis and gave up their mounts for motorized vehicles when they were federalized by Gen. George S. Patton in 1942.

The end of World War II brought a new beginning to the WHC, which continues today. The WHC recognizes that without the military reservation the beautiful open landscapes used for military training would not be available to ride to the hounds, and their centuries-old tradition would cease to exist.

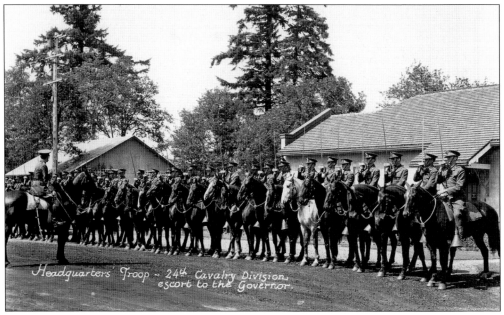

THE 24TH CAVALRY DIVISION, C. 1938. Washington National Guard, Headquarters Troop, 24th Cavalry Division, is the oldest military organization in the state and is headquartered at Camp Murray, Fort Lewis. The governor is in charge of the Washington National Guard and performs periodic inspections. Here they are at attention to the governor, swords drawn. (Courtesy Tacoma Public Library.)

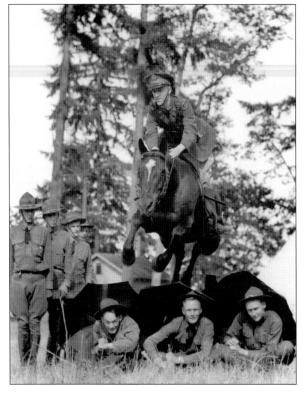

TROOP B JUMPING. Tacoma's famous Troop B demonstrates some trick riding at the 1935 encampment. Troop B is part of the 24th Cavalry Division, Washington National Guard Headquarters Troop, located near WHC. A guardsman on a horse jumps over three of his fellow national guardsmen under umbrellas. This c. 1935 group was part of the 7,000 enlisted men and 600 officers taking part in the 15-day field training. (Courtesy Tacoma Public Library.)

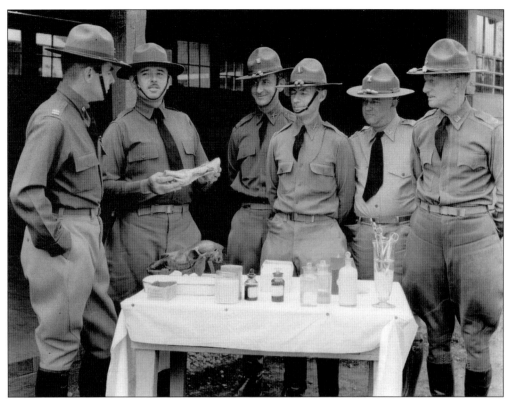

VETERINARY INSTRUCTION. Officers' Reserve Corps members receive veterinary instruction in July 1934 at a combined Officers' Reserve Corps, Civilian Military Training Corps (CMTC), and ROTC training at Camp Murray. From left to right, Capt. John G. White, Captain Leighton, Lieutenant Molloy, Major Clayton, Lieutenant Colonel Hauser, and Col. George Weisel examine the medical supplies, equine skull, and leg bone on the table. (Courtesy Tacoma Public Library.)

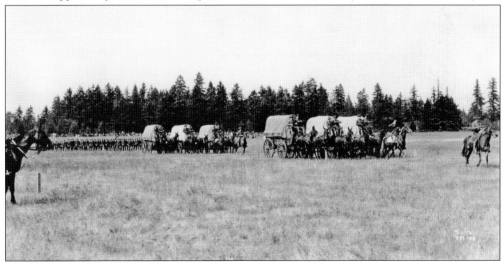

ENCAMPMENT. This 1934 parade at the Washington National Guard Encampment at Camp Murray features covered wagons pulled by horses on the Nisqually Prairie. The prairie grasses provided food for the horses, just as they did for the Nisqually tribal horses. (Courtesy Tacoma Public Library.)

FEEDING THE YEARLING. A Washington State National Guardsman takes time out to feed a colt by hand at the 1935 encampment at Camp Murray. The camp held a 15-day field training course offering special schools in chemical warfare and ordnance. (Courtesy Tacoma Public Library.)

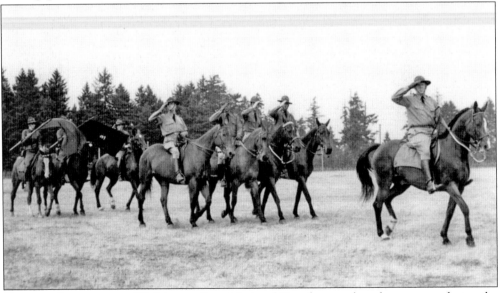

GENERAL PENNINGTON. Washington State National Guardsmen salute the governor during the 1935 review of troops. Gen. Carlos A. Pennington of Tacoma and his staff salute as they pass the reviewing stand on horseback. (Courtesy Tacoma Public Library.)

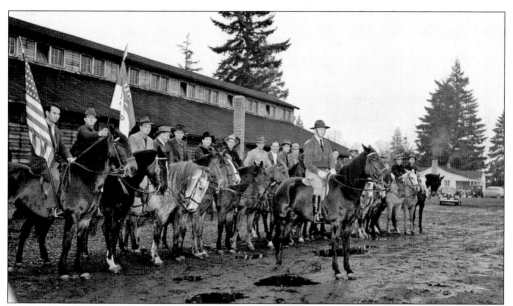

WORLD WAR II. Woodbrook activities were suspended for World War II. The arena was turned into a government box factory; the clubhouse was rented for military housing. Many members volunteered to patrol the Pacific Coast on horseback with the Home Guard Mounted Troops. Art Hannum holds the American flag; Cyrus Happy III is mounted fifth from left; and Lt. J. J. Mellinger, commander of the Mounted Troop, Home Guard, is mounted in front. (Courtesy Tacoma Public Library.)

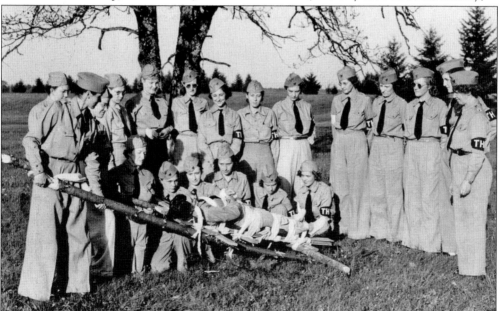

WOMEN'S EMERGENCY MOTOR CORPS. Thirty members of the Women's Emergency Motor Corps were taking part in drills at the WHC grounds around 1941. The Women's Emergency Motor Corps studied and practiced first aid, emergency transportation, Morse code, motor mechanics, map reading, and emergency communications to support the war effort and to offer aid as needed. Iris Bryan, a hunt club founding member, was elected by the group as its leader. (Courtesy Tacoma Public Library.)

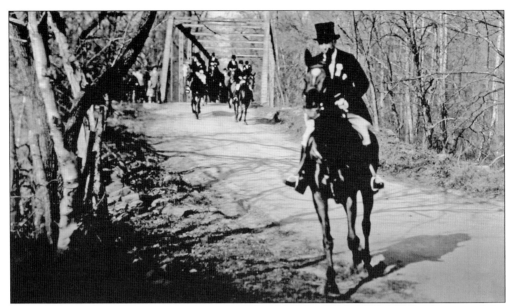

GENERAL PATTON, C. 1933. Gen. George S. Patton assisted with the mechanization of the Wyoming 115th Cavalry stationed at Fort Lewis and hunted with WHC. Patton was alerted that Lipizzaner stallions were at risk and placed them under U.S. Army protection for the duration of the war. Brookwood Equestrian Center has since hosted the Lippazans. This photograph is of General Patton foxhunting at Middleburg Hunt, Virginia. (Courtesy Howard Allen Studios.)

THE 115TH CAVALRY. The Wyoming 115th Cavalry was mobilized to Fort Lewis in 1940 and was reorganized and dismounted in 1942. Marvin Carpenter, Headquarters Troops, C Troop, married Cecelia Svinth Carpenter, great-granddaughter of Charley Ross (HBC) and Catherine Tumalt Ross, Nisqually cousin to Chief Leschi. Cecelia grew up riding horses on the Nisqually prairie. Her husband's cavalry troop was mechanized by General Patton and fought in the Battle of the Bulge. (Courtesy Cecelia Svinth Carpenter.)

Ten

FUTURE LEGACY?

What legacy lies ahead for the prairies south of Tacoma? The last three percent of South Puget Sound prairies have witnessed tremendous change, including occupation by three different nations (Nisqually people, Great Britain, and the United States), and have been the site of much political turmoil. Yet the prairies south of Tacoma have experienced a timelessness that one can feel today: the solitude and quiet of the prairie; the wind blowing in your face, blowing the prairie wildflowers; the music of chirping birds and croaking frogs. The Nisqually people say the prairie grasses blowing in the wind are their ancestors' spirits dancing.

It is indeed a strange turn of events that somehow preserved the last three percent of Nisqually Prairie to retain the landscape, the flora, the fauna, and the activities much as they have been for the past several centuries. It is a legacy our forefathers and foremothers have somewhat by chance left us, rather than by design. Today there are public policy choices to be made in the near future that will have a significant impact on whether or not this unique ecosystem will survive for future generations.

Some conservation groups have already identified the issues and have begun to take steps to prevent further loss, while other significant regional influences continue to push public policy forward in the name of progress without full understanding of the implications of losing this legacy for future generations. A careful, deliberative process is needed to ensure decisions made today balance short-term benefits against any negative impacts to future generations.

The legacy of the prairies south of Tacoma continue to face many challenges, both man-made and those by Mother Nature. The challenges will come from many fronts, some apparent, some less obvious. Both require stewardship and attentiveness to ensure the inherited legacy can be passed onto future generations, so our children's children's grandchildren can see, experience, and enjoy the natural beauty and wonder of the prairie habitat ecosystem. Only time will tell what the future holds for the legacy of the prairie south of Tacoma.

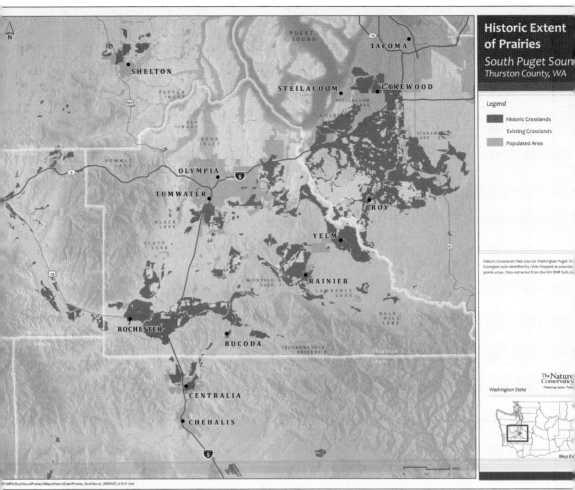

ONLY THREE PERCENT LEFT. This *c.* 1998 Nature Conservancy map shows the historic extent of the prairies in South Puget Sound. Only three percent of the original prairie still exists. Development and invasive plant species are the two primary threats to the prairies south of Tacoma. The Nisqually Prairie provides habitat to over 35 endangered plant and animal species. The last three percent of the prairie is isolated in patches on Fort Lewis near WHC, south of I-5, Yelm, and Roy. (Courtesy The Nature Conservancy.)

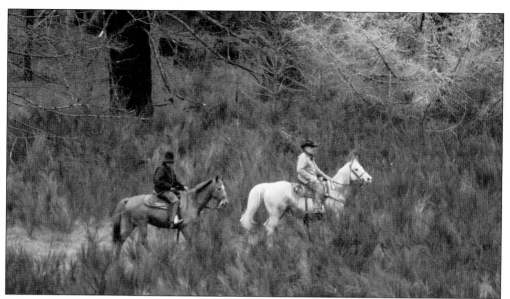

INVASIVE SPECIES. Scotch broom is considered one of the most significant threats to the prairie grasslands. Fir trees are also considered an invasive species for prairie lands and oak habitat. When seasonal burning of grasslands practiced by the Nisqually people ceased, the invasive species began to encroach onto these ecosystems. Climate changes may also pose a threat to the prairie ecosystems. Fort Lewis, The Nature Conservancy, and other conservation groups have partnered to protect and enhance the last three percent of the remaining prairie lands. Andrea Keniston, Brian Keniston (kneeling with dogs), Karen Keniston (mounted left), Kelsey Longrie (standing), Joy Keniston-Longrie, Amber Longrie, and Kelly Keniston pose at a location, which reflects triple threats: scotch broom, fir trees, and proposed highway alignment. This location is near the old Dean land claim at Tlithlow, where Sunday horse races took place in the 1850s. (Above, courtesy Poulsen Photography; below, courtesy Rick Keniston.)

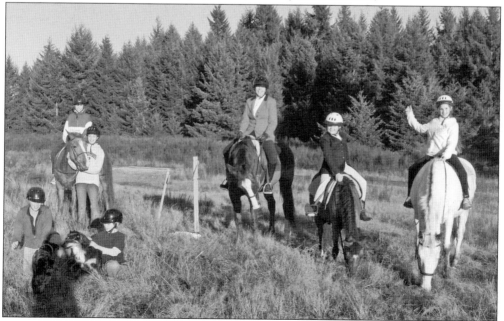

PROPOSED HIGHWAY. The proposed route for the Cross Base Highway runs near the existing Woodbrook facilities and would destroy the last best remnants of prairie lands, oak groves, and wetlands left on the South Sound Prairie. Surveyor flags mark the proposed alignment of the six-lane highway that will cut off access to and end a century of tradition of riding to the hounds. The highway would pose a threat to the existing equestrian facilities, whose operations would be incompatible with it. (Both courtesy Rick Keniston.)

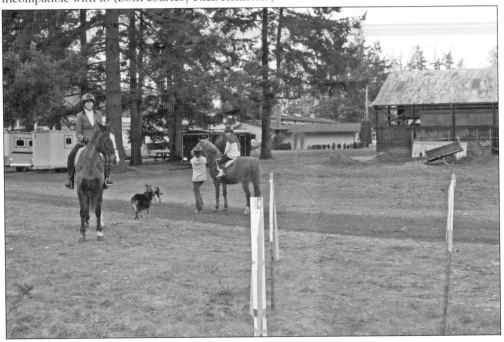

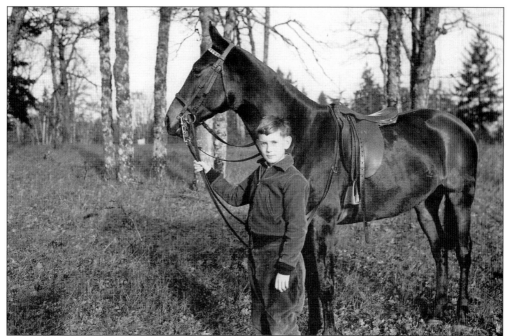

FUTURE LEGACY? Harold Allen is the young boy under oak trees on the prairie around 1936. Major public policy choices will be made today that will affect what legacy will be left to current and future generations in terms of habitat, endangered and threatened species, ecosystems, equestrian recreational use, and quality of life. Let us hope that today's decision-makers carefully weigh short-term benefits against intergenerational equity for social, economic, and environmental benefit. (Above courtesy Tacoma Public Library; below courtesy Felicidad Langston Collection.)

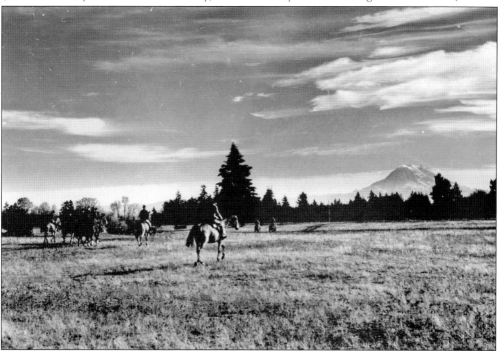

ACROSS AMERICA, PEOPLE ARE DISCOVERING SOMETHING WONDERFUL. *THEIR HERITAGE.*

Arcadia Publishing is the leading local history publisher in the United States. With more than 4,000 titles in print and hundreds of new titles released every year, Arcadia has extensive specialized experience chronicling the history of communities and celebrating America's hidden stories, bringing to life the people, places, and events from the past. To discover the history of other communities across the nation, please visit:

www.arcadiapublishing.com

Customized search tools allow you to find regional history books about the town where you grew up, the cities where your friends and family live, the town where your parents met, or even that retirement spot you've been dreaming about.